Warm Wishes Spencer...
Hope to see you on Block Island
and hear all about Washington —

ρ Χω (Peace)

Debbie Doyle
2016

# FACES OF
# EGYPT

*For Justin Doyle, who was adventurous and took*
*a new job in Egypt, and for our grandchildren, Cate,*
*Leah, Emma, Tom, Shea, Annabelle, Maeve, and Grace,*
*with hopes that they will be curious and open-minded*
*when exploring other cultures.*

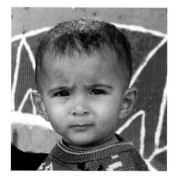

# FACES OF EGYPT

## IMAGES AND OBSERVATIONS

### BY DEBORAH SHEA DOYLE

Interlink Books

An imprint of Interlink Publishing Group, Inc.
Northampton, Massachusetts

First published in 2014 by
INTERLINK BOOKS
An imprint of Interlink Publishing Group, Inc.
46 Crosby Street, Northampton, Massachusetts 01060

www.interlinkbooks.com

Library of Congress Cataloging-in-Publication Data
available
ISBN 978-1-56656-964-4 (hardback)
ISBN 978-1-56656-961-3 (paperback)

Founder/Publisher/Editor: Michel S. Moushabeck
Book Production and Design: Geoffrey Piel
Copy-editing: Hilary Plum
Proofreading: Jennifer Staltare

Printed and bound in China

To order our complete 48-page, full-color catalog,
please call us toll-free at 1-800-238-LINK,
e-mail us at sales@interlinkbooks.com,
or visit our website at www.interlinkbooks.com.

# Contents

*Introduction*                              1

Bedouin of the Sinai                        2

Everyday Life                              28

Children                                   34

Food                                       46

Women                                      58

Men                                        74

Crafts                                     90

Islam and Christianity                    102

An Egyptian Legend                        112

*Acknowledgments*                         114

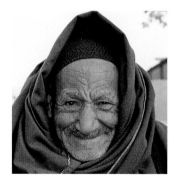

# Introduction

As a child, I listened to my Aunt Wilma describe in detail the awe she felt when she descended the steep stone steps of King Tutankhamen's tomb shortly after it was opened to the public. She remembered the beautifully colored wall reliefs and stone sarcophagus with its mummy still inside. Late in life, when the names of family members had faded from her memory, she could still describe her fear when caught in a Sahara sandstorm while riding a camel, and the thrill of climbing twenty meters up the steep side of Khufu's Pyramid.

In high school, I combed the shelves of the Rochester, New York, public library for books of historical fiction centered in Egypt. I dreamed of one day traveling down the Nile, or climbing deep into a 4,500-year-old pyramid.

In 1993, a Foreign Service legal job for my husband with the Agency for International Development (USAID) took us to Egypt for four years. We studied Arabic at the US Embassy, and I began teaching job-specific English to Egyptians working there. This part-time job gave me up-close contact with all levels of Egyptian society, from maintenance workers, drivers, and local guards, to highly educated Egyptians working in the political or economic sections of the Embassy.

It also gave me free time to explore the streets of Cairo, camera in hand. I have always enjoyed photographing people. Egypt presented a gold mine of opportunities to capture and record interesting faces. I peered into workshops, purchased food from street vendors, and sat in outdoor cafés for hours watching and photographing the bustling life of a crowded, teeming, noisy city.

Egyptians are a gracious and welcoming people. They applauded my tentative attempts at Arabic, giving me courage to keep talking despite how I was murdering the grammar. I drank tea in the apartment of a family matriarch in the City of the Dead, while watching the video of her son's wedding on a black-and-white TV. I tramped through farmland in the Saqqara area to watch women weed fields of greens and old men harvest onions and tomatoes. I talked with women in Mokattam as they sorted though piles of garbage collected by their husbands and sons. Barefoot children with homemade toys smiled and waved as I walked by, and a uniformed schoolgirl shyly asked, "How are you?" in halting English. I have always seen a timeless look in the faces of older Egyptian men and women, strength despite adversity. All willingly agreed when I asked *"Mumkin soorah?"* (May I take your picture?)

We returned to Egypt for a second time in late 2000, and lived in El Gorah, Northeast Sinai, for almost seven years. My husband took a new job as Force Counsel with the Multinational Force and Observers (MFO), a peacekeeping organization monitoring the Peace Treaty between Egypt and Israel. This posting allowed me to explore the entire Sinai region, and enabled me to learn more about the lives of Egyptians, especially the Bedouin people.

While I was in Egypt, the Sony Gallery of the American University in Cairo exhibited my photographs at a show entitled "Faces of Egypt." They were also shown at the Community Services Association in Maadi and at an exhibition at the Canadian Embassy. For five years while we were in the Sinai, I created 400 calendars with original photographs and marketed them, along with my photo cards, at galleries and bazaars in Cairo. All the money raised was donated to Egyptian charities that benefited women and children.

In this book I present pictures of ordinary Egyptian men, women, and children as they work and play in their everyday lives. I also describe my experiences while photographing and talking with them. My Egyptian friend Magdy told me he more fully appreciated the lives of many people of Egypt after seeing my pictures. Through these photographs and memories of our ten years in Egypt, I hope you will come to know and understand more about the lives of a wonderful people—gracious, warmhearted, hardworking, and resourceful.

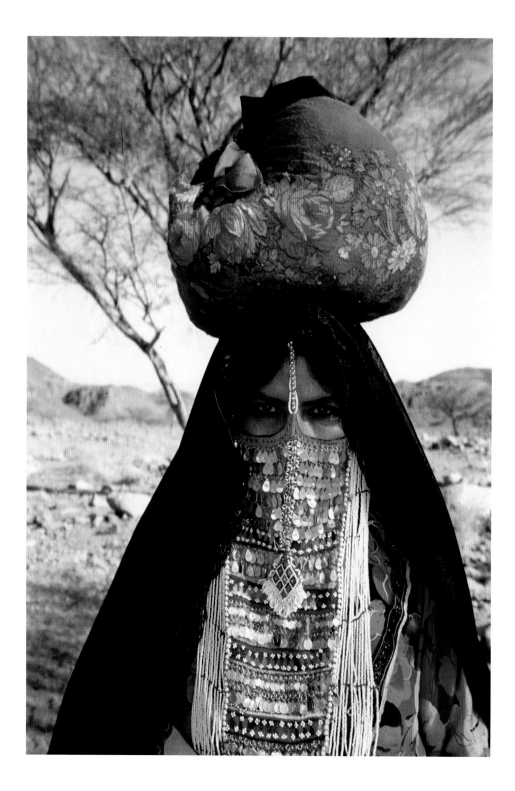

## Bedouin Woman
## South Sinai

I awaken at about 6:30 AM, feel the cold desert air on my face, and struggle to roll over in my narrow sleeping bag on the hard ground. Unzipping the tiny tent, I peek through the opening. Other campers are outside stretching stiff arms and legs. I smell coffee and *fool* made from fava beans warming over an open fire.

Looking up at the huge 750-foot rock outcropping known as Serabit el-Khadim, with a Pharaonic temple from the Twelfth Dynasty at its summit, I think of the climb to see it the day before. My legs shook as I inched my way along the narrow rock ledges on the west side of the outcropping, slowly making my way to the temple. It was worth the climb. The descent to the campsite on the other side was a bit easier; grilled chicken around the campfire tasted delicious before we fell asleep in our tiny pup tent.

Once outside the tent in the morning, I spot a row of veiled Bedouin women sitting silently in the rosy early morning light. Colorful scarves are laid out in front of them, covered with their handcrafts— brightly beaded necklaces, bracelets, rings, and even a toe ring connected to an ankle bracelet with yellow and red beads.

One woman displays scarves with beads and coins dangling from them, and cloth purses colorfully embroidered with floral and geometric designs. I sit down before her and am transfixed by her dark eyes, which seem to pull me into her soul. Because of her veil, only her eyes peer out at the world. We talk in Arabic, and I purchase two of her intricately embroidered purses. Then she carefully wraps her wares in a scarf and places the bundle on her head. I take her picture.

She writes her address in Arabic, and I promise to send her the pictures. The address is a gas station about 35 kilometers away on a main road leading to Sharm el-Sheikh. The station also serves as an informal post office for the Bedouin in
the area.

She has her picture now, but does she realize how many other people also have her picture, and admire her beautiful veil and haunting eyes?

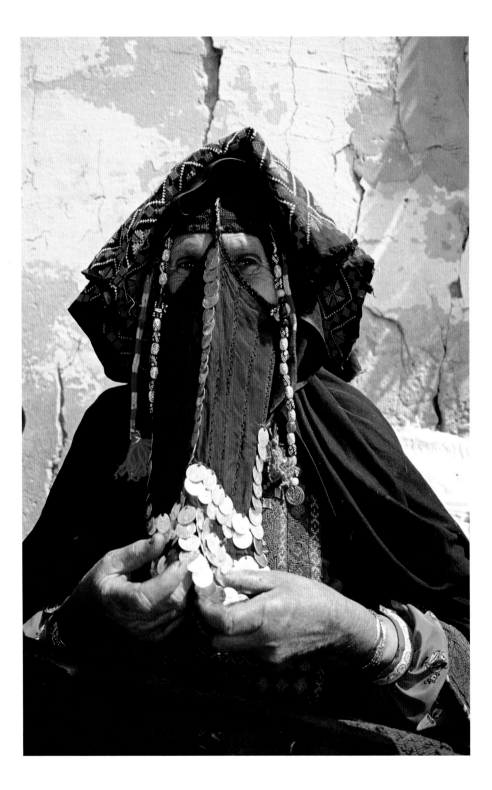

4

## Bedouin Market – Al-Arish

Thursday is market day in al-Arish. People from the area bring produce, live animals, handmade household goods, new and used clothing, and beautiful hand-embroidered Bedouin craft products to the market.

This is a great way to meet the "locals," as they say, and a perfect place for a photographer. My favorite section of the market is where old Bedouin women display their embroidered goods.

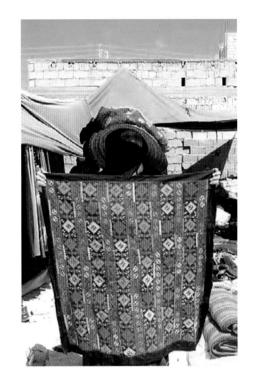

I sit down and talk with a woman whose traditional face-covering draws me in. Carefully sewn old coins jingle from its sides and bottom. Handmade pottery beads swing like braids from the sides. Tiny red, blue, and white stitches forming geometric designs on the bib of her dress can be seen beneath her veil. Her eyes smile as we talk.

Other women nearby call to me to buy their large pieces of fabric covered in colorful cross-stitched patterns. Each piece represents at least two or three months' work.

In another section I watch a man making a circular sieve for separating grain from chaff. Nearby, I can't resist buying a kilo of fresh green peas from a smiling farmer in blue. I return home with many Bedouin crafts, delicious vegetables, and photographs to remember a fascinating day.

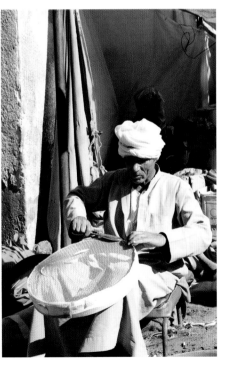

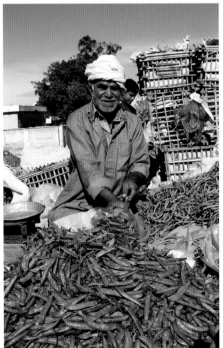

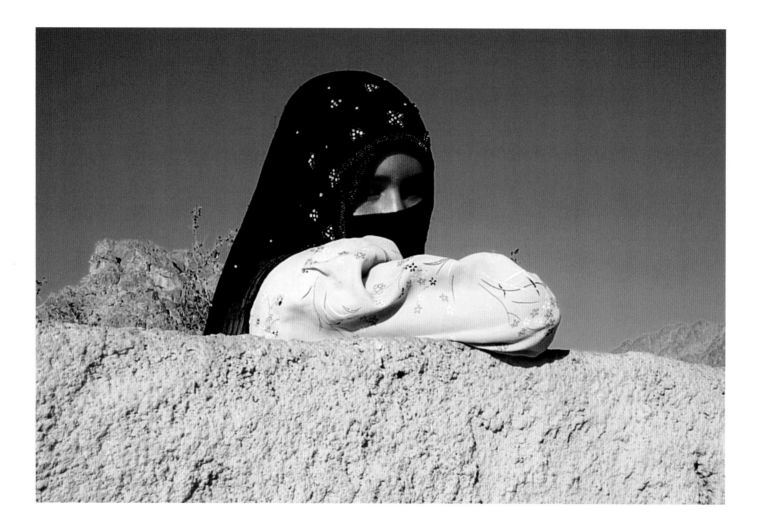

## Women and Walls
## South Sinai

Egyptian women spend much of their time in the home. In the evening, the men go to nearby cafés to drink tea, smoke *sheesha*, watch soccer games, and talk with friends, while the women clean up from dinner, iron clothes, and care for the children. At prayer time, the mosque fills with men. The few women who come remain at the back, sometimes sheltered behind a green curtain. Most women pray in the confines of their home.

The woman in blue gazes from the doorway of the courtyard of her home in Nuweiba. The young girl at the left looks pensively at me from the protection of the walled courtyard of her wadi (a dried-up streambed) home near St. Catherine's Monastery in the Sinai.

*What are they thinking? I wonder. Do they wish for more freedom, for more choices in their lives? Are the stuccoed walls a metaphor for a walled-in life?*

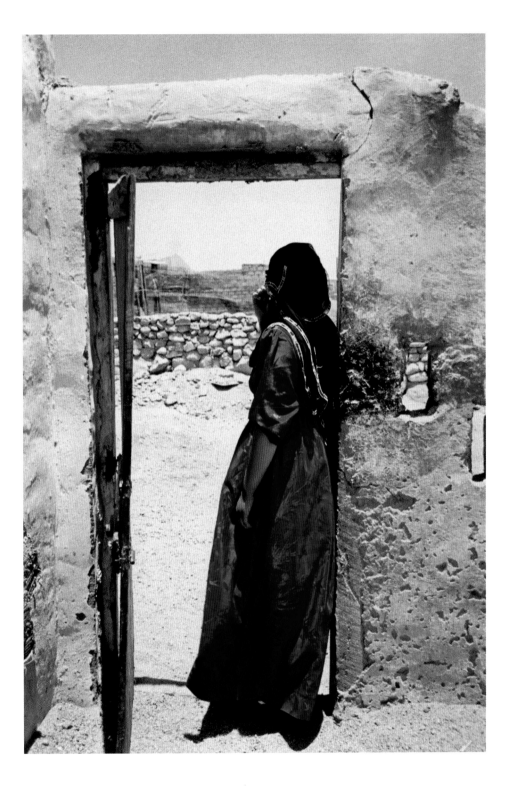

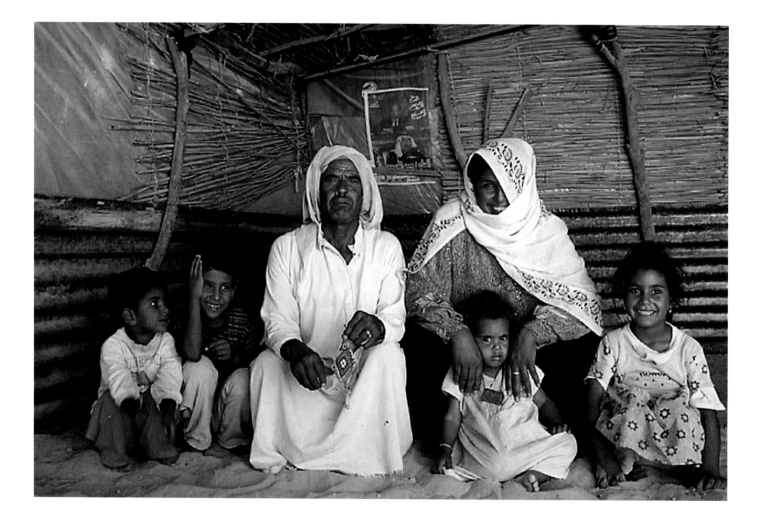

8

## Bedouin Family Life

A young curly-haired girl in a yellow print dress smiles broadly and waves to me from the side of an isolated road in the Sinai. As I stop my car and get out, three more barefoot children suddenly appear.

A large woman in a long black skirt with a white printed headscarf appears in the doorway of a small cement-block house. I wave and she motions for me to come in. The excited children plead with me to come. I grab my purse, with pictures of our grandkids, camera, and pencils for the children, and head toward the house. The girl in yellow takes my hand tentatively, while the others scramble alongside.

*"Ismi Hoda,"* I'm Hoda, the woman says as she points to the hooch, a lean-to type structure made of discarded corrugated metal and bamboo and connected to the house. Bedouin often receive visitors in their hooches rather than their small homes. We take off our shoes, and sit on cushions on the sand floor. Hoda brings hot mint tea in small glass cups; we chat about her children, and I show her pictures of my grandchildren, always of great interest to women in remote areas of Egypt.

Hoda's husband, a much older, rather gruff man, with steely brown eyes and a downturned mouth, comes in. *Hoda must not be his first, or only, wife,* I think. Hoda stops her questions and seems ill at ease after he sits down; nevertheless, the whole family willingly poses for my camera under a picture of the local sheikh.

I finish my tea, say my goodbyes, and walk back to my car with the children. They shout *"ma'a salaama,"* goodbye, as I drive away. A few weeks later, when I return with several copies of this picture mounted on heavy cardboard, Hoda smiles, grabs my hand to thank me, and tells me it's the only picture she has of her family.

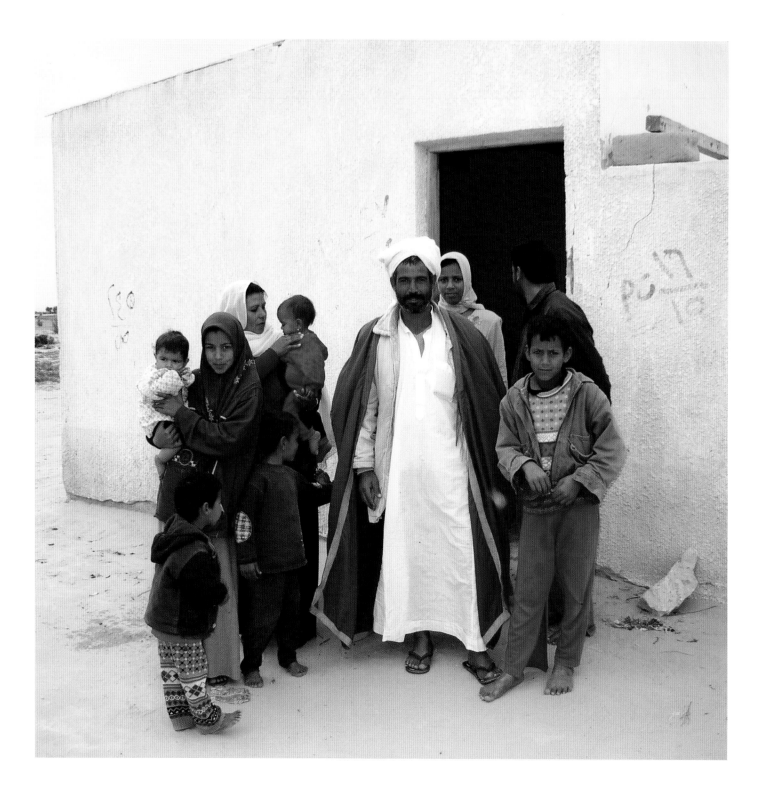

## Friends with a Bedouin Family

I drive toward al-Arish on a remote desert road about fifteen kilometers from Rafah in the North Sinai. In a field near the road, two teenage girls are gathering leaves and roots from desert plants and herbs to use for medicine. When I stop and chat in Arabic, they invite me for tea, pointing to a house down the road. This is the beginning of a three-year friendship with a large extended Bedouin family. Armana, a mother of six, is expecting again. She appears tired but happy. She introduces me to her sister Salwa and Salwa's sixteen-year-old daughter. I wonder if Salwa is jealous of her sister's large brood.

Revisiting my new friends a few months later, I learn that Armana has delivered twins—a boy and a girl! She nurses her new babies while we drink tea. She points to her still-stretched-out stomach, and asks in Arabic if I know of anything that may help to pull in her stomach. I promise to look for something when I'm in the states that summer.

Several months later, I return with warm sleepers for babies Kamel and Nabila and a huge bag of little-used clothing from our grandchildren. Armana smiles broadly and says *"Shukran,"* thank you, when I present her with a new pair of underpants complete with a spandex panel to help hold in her stomach. Kamel models his new outfit and they bring one of the family's rabbits to show me. He holds the rabbit by its ears for all to see. Soon the family will have the rabbit for dinner.

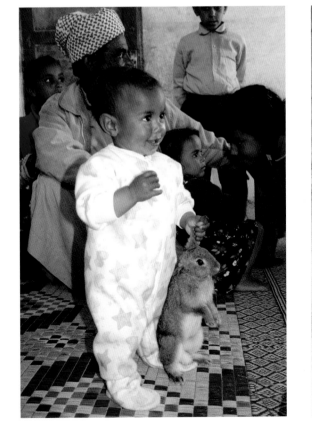
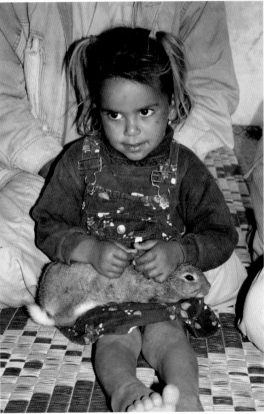

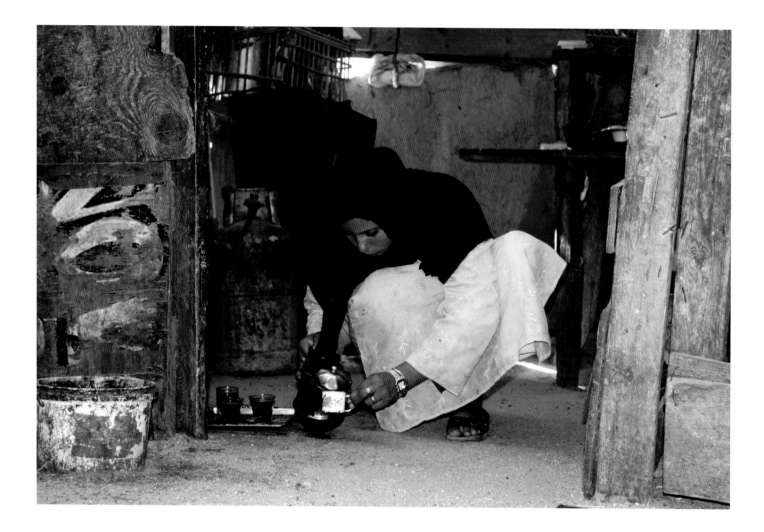

## Please Come in for Tea

"Please come in for tea," a woman's soft voice greets me from the entrance of a small house constructed of discarded plywood and tarps. Strangers are always welcomed in the Arab world, and despite age, language, and cultural differences, women can connect the world over.

Deep in a wadi, a dried-up ancient riverbed, about 65 kilometers from Sharm el-Sheikh in the South Sinai, I take off my shoes and sit on a mat with Nabila and four curious and squirming young boys and girls, while her friend Selma squats over a small butagas stove heating the water. Hot tea with lots of sugar is served in small glass cups. We brush flies from our faces and the rims of the cups as we drink and smile at each other.

I take out pictures of my children and grandchildren and converse in hesitant Arabic about them. Selma and Nabila examine the pictures carefully, and ask where they live, how old they are, and what their houses look like. My husband stays outside with the men, sitting and talking on a plastic mat in the intense Sinai sun.

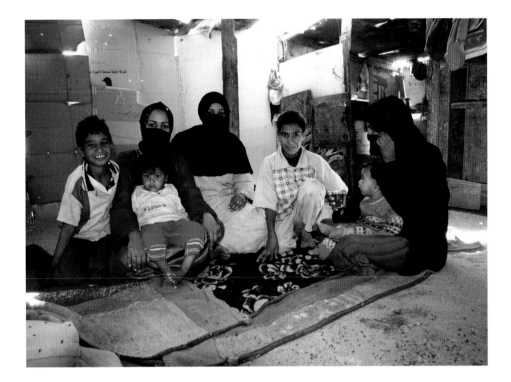

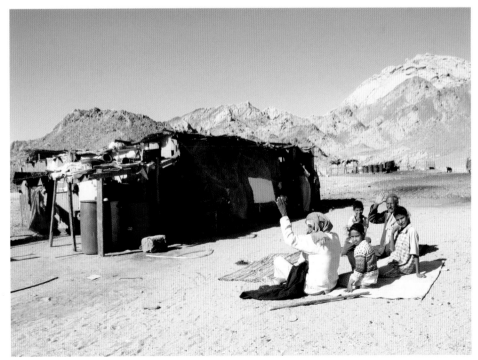

Bedouin of the Sinai

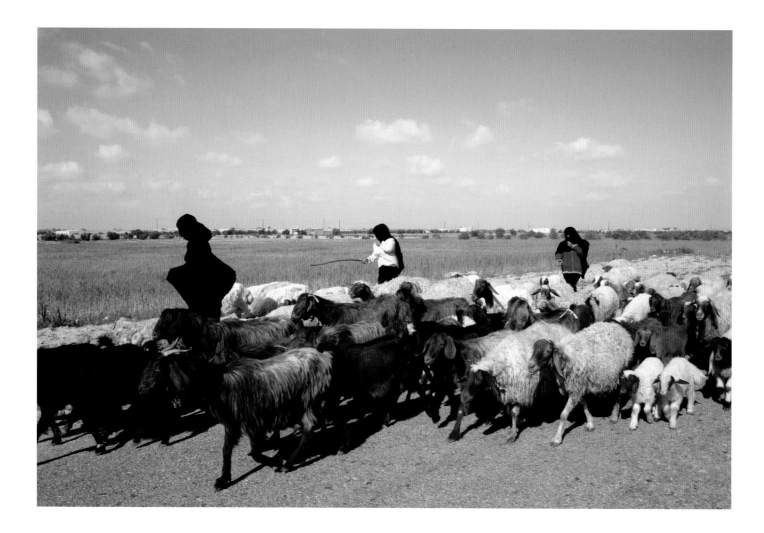

Faces of Egypt

## Along the Road near Al-Arish

Late one afternoon, while driving along a desolate stretch of road in the North Sinai, I spot a group of three young women returning from watching their large herd of goats and sheep graze in a distant field. I stop to chat, but they quickly turn and cover their faces as I shoot a picture. Farther down the road in a small settlement, I encounter a different reaction. A large group of children wave and signal me to stop. I roll down the window, talk briefly with them in Arabic, and hand out pencils to their eagerly outstretched hands.

Toward the back of the group, a young girl with huge sparkling eyes points to a yellow mud-covered house and motions to me to come with her. She is so insistent that I agree, and we walk along the road and into the dirt yard surrounding her house. The smell of freshly baked bread drifts from a brick oven in the rear of the yard. It contrasts with a strong barnyard smell coming from several animal enclosures constructed of dried sticks, branches, and thick grasses. The largest enclosures are for the goats and sheep still grazing in nearby fields.

The girl takes my hand and leads me into a tiny enclosure where a newborn brown baby goat cuddles up to its mother. "He's one month old and he's mine," she tells me as she tenderly lifts him into her arms.

We walk to her side yard, and she embraces him while I take her picture. I think of her beautiful smile and love of her goat each time I pass her house.

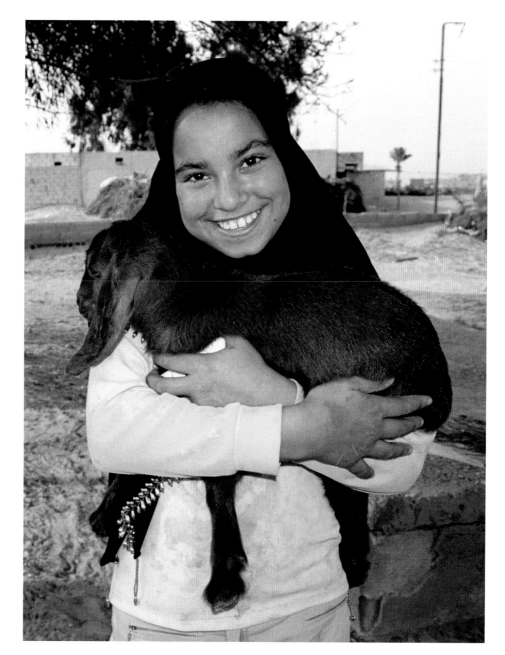

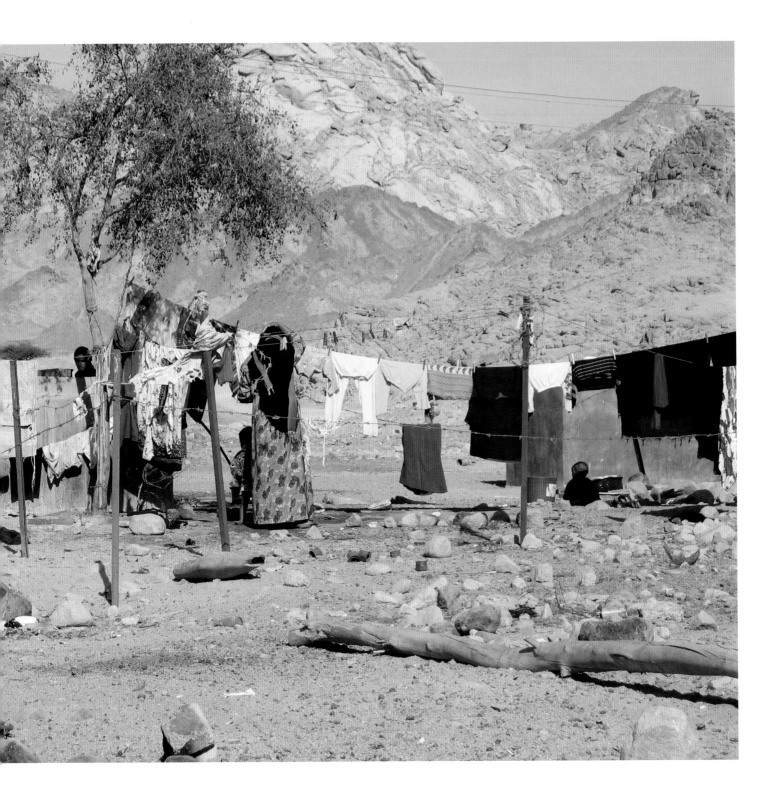

## Deep in a South Sinai Wadi

Many Bedouin in the South Sinai live back in beautiful isolated desert wadis far from any town or village. The majesty of the stark rocky outcroppings on either side of the sandy wadi, along with an occasional acacia tree and desert bushes, captivate me as I drive far into a wadi 40 kilometers from Sharm el-Sheikh.

It's a crisp clear day; the sky is bright blue without a cloud in sight. I'm amazed to come upon a desolate Bedouin home roughly constructed of discarded plywood and canvas tarps. Next to the house a woman in a bright blue and red *galabeya* hangs out hand-washed clothes while her children play nearby. The bright clothing contrasts sharply with the wadi around her. I lean out and snap a quick picture to help me remember the beauty of the moment.

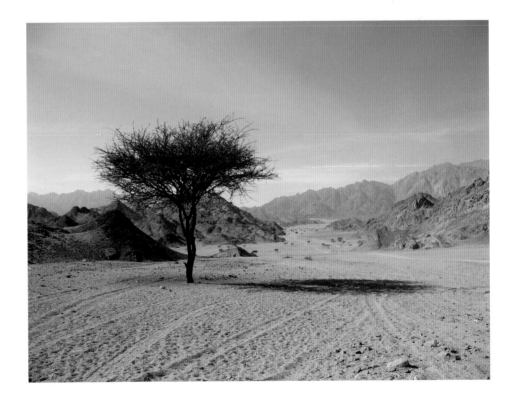

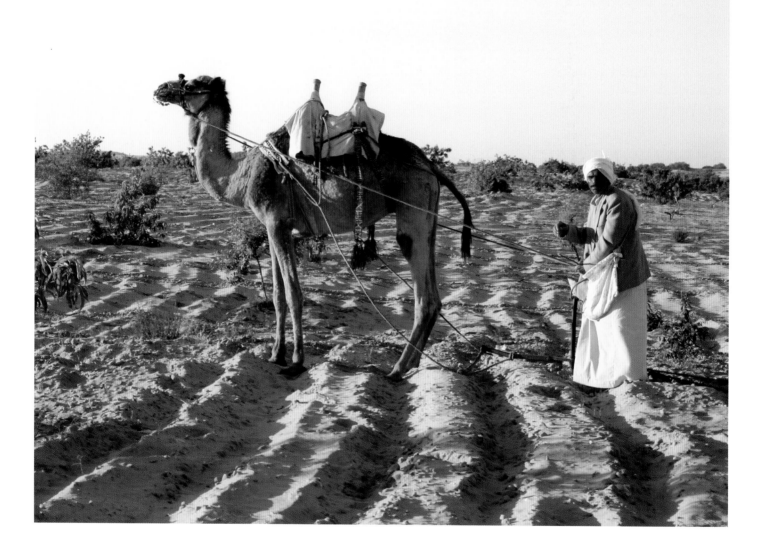

## Along a Sinai Road

Donkeys are the beasts of burden for the Bedouin. Under merciless whipping, they haul carts heavily laden with butagas containers or with uniformed children on their way to grammar school. Donkeys often pull the plows as Bedouin men plant their fields.

I am surprised, therefore, to see a camel drawing an iron plow of the same type as those used 3,000 years ago in the Middle East. The camel's driver stops as I trudge across the rippled sandy field in the pinkish fading light of a late Sinai afternoon. He poses proudly with his prized possession; when I return with this picture a few weeks later, he smiles happily and tucks it carefully into his pocket.

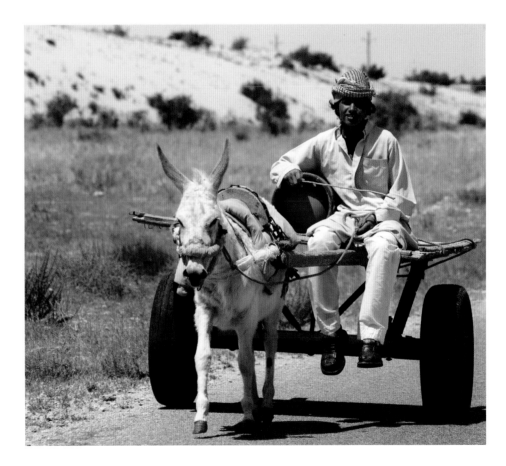

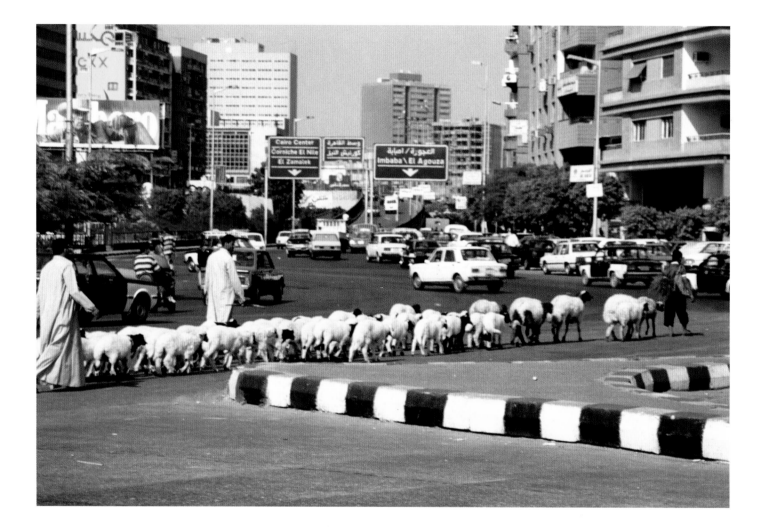

## Driving in Egypt

Driving in Egypt is a challenge. Cars come at you from all directions. Drivers seldom stop for red lights unless a traffic policeman is at the intersection. Most drivers fail to observe lane markers—four to five cars travel abreast in lanes marked for three. Drivers seldom use lights at night. "We must save the bulbs and the battery," they explain. Horns honk incessantly despite a law forbidding it.

A pickup truck with a load twice its height leaning precariously to one side passes by. Be on the watch for as many as thirty goats to cross in front of you, or a donkey cart to head down a one-way street toward you.

One day a hobbled camel ambles across a Sinai road in front of us, and on another day, an ox led by his owner breaks free and careens down a crowded street just missing our car!

The microbuses present the greatest challenge for all drivers in Egypt. These crowded, battered vans, spewing smoke, zigzag through traffic with doors open and people jumping on and off as the vans slow down. This is the fast pace of life in Egypt.

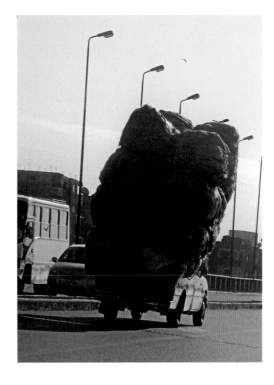

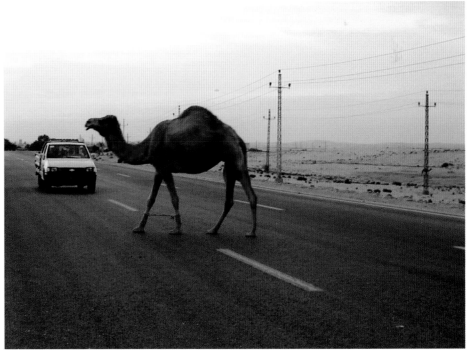

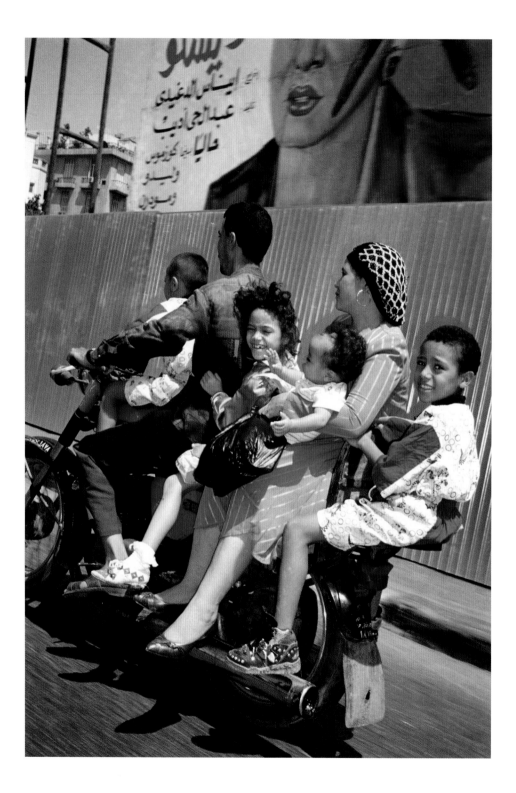

## Out for a Ride, Cairo

It's Friday morning. Cairo's usually teeming streets are quiet as many prepare for noonday prayers at the mosque.

"Slow down, Jud!" I call out to my husband as I spot an overloaded motorcycle start to pass us on the right. I love to photograph motorcycles carrying more than one person. I recently shot one with four boys in their twenties out for a ride, but this one has even more!

I grab my camera, roll down the window, and lean out as a family of six pulls up alongside. They are dressed in their "Friday best," probably heading for a visit to parents and grandparents. The mother, sitting sidesaddle and precariously balancing her baby on her lap, nods consent to my camera. I click away. They smile at my attention.

After I shoot more than a dozen photos, the motorcycle turns off down a side street and they wave goodbye. My only regret is that I can't give them this picture—maybe the only color photo they'd have to remember their Friday morning ride in Cairo.

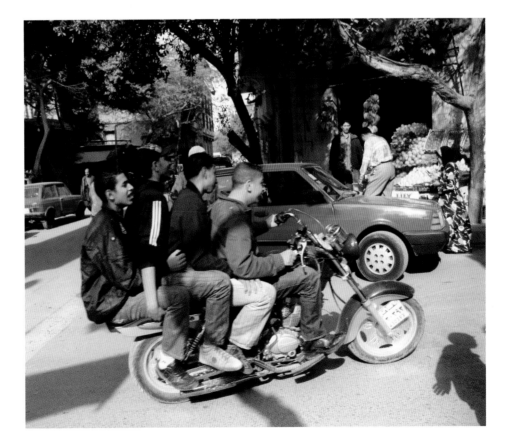

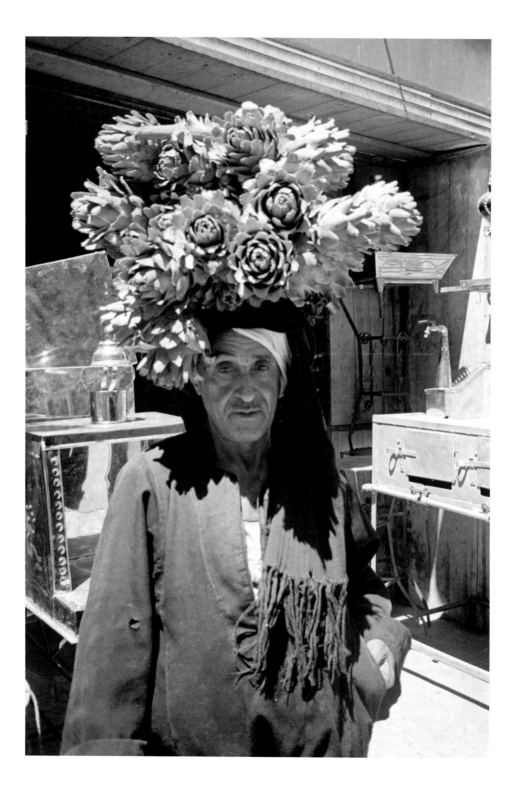

## Shopping in the Khan el-Khalili

The Khan el-Khalili is the central shopping area of Cairo. The shops near the al-Hussein Mosque cater mostly to tourists, led on by flag-waving guides herding them past shop after shop of alabaster, silver, copper, brass, or gold.

"Special price for my first customer," shouts a pleading shopkeeper who features shiny hand-blown glass perfume bottles and Christmas ornaments of all sizes and shapes.

"We love Americans," calls out another, who offers intricate inlaid boxes and handmade oriental carpets and *kilims*.

Unlike the tourists, Egyptian shoppers go deeper into the warren of alleys and shops seeking everything they need for house and home. In the fabric and clothing area, completely covered women come to buy the brightly colored clothing they wear when they remove their dark outer garments at home.

Another section features bras and panties that would make a Victoria's Secret model blush. "Artichoke man," as I call him, walks the alleys of the produce section with a cluster of fresh artichokes perched on his head. He takes his "hat" off, I select two, he carefully cuts them off, and I take them home for dinner.

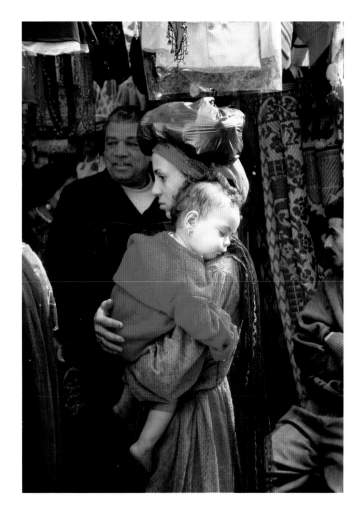

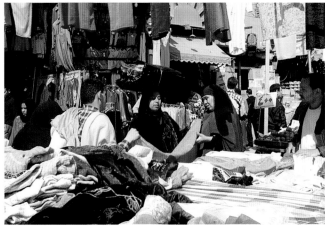

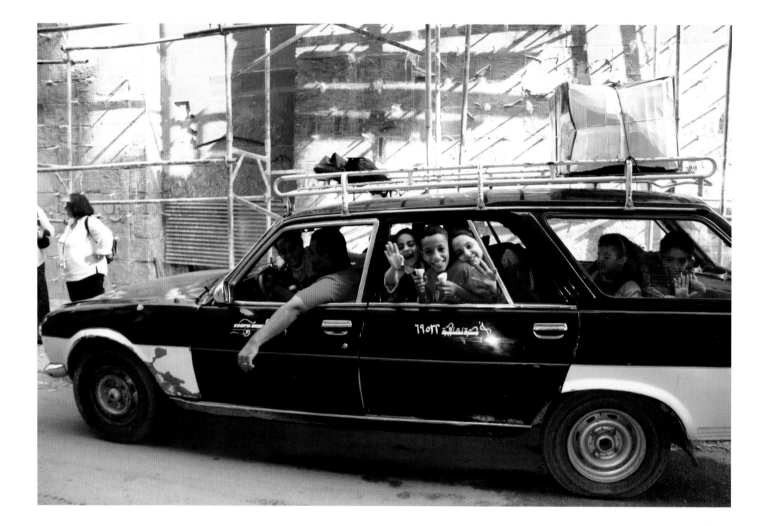

## Cairo's Taxis

It's always an adventure to ride in a taxi in Cairo. There are shiny well-cared-for cabs, cabs with multiple dents and dings, cabs with cracked windshields, and cabs with starters that don't work. My only criterion for entering a cab is that it have a rear door handle so I can escape if necessary.

During one of my first cab rides in Cairo, the cab chugged to a halt on a busy street. The driver got out, raised the hood, and I could see him press two dangling wires together, causing an enormous spark. He quickly jumped back into the cab as it moved down the street! He turned and gave me a huge smile and a thumbs up.

On another day, a donkey broke free from pulling a cart filled with garbage and ran down the crowded street, narrowly missing my cab.

Many cabs have velour draped across the dashboard. Prayer beads and the hand of Fatima dangle from the rearview mirror. Pictures of children and grandchildren (never wives) are proudly displayed along with small plastic dolls or stuffed animals. Arabic music or prayers blast from rickety radios while fumes spew from rear exhaust pipes.

Peugeot three-seaters overflowing with people are a common sight. I passed one on the Corniche crammed with sixteen uniformed schoolchildren—four boys in front, six girls squeezed into the second row and six more boys jammed into the third. Sixteen backpacks were neatly stacked on the roof.

This Peugeot only carries nine squirming children on their way home from school!

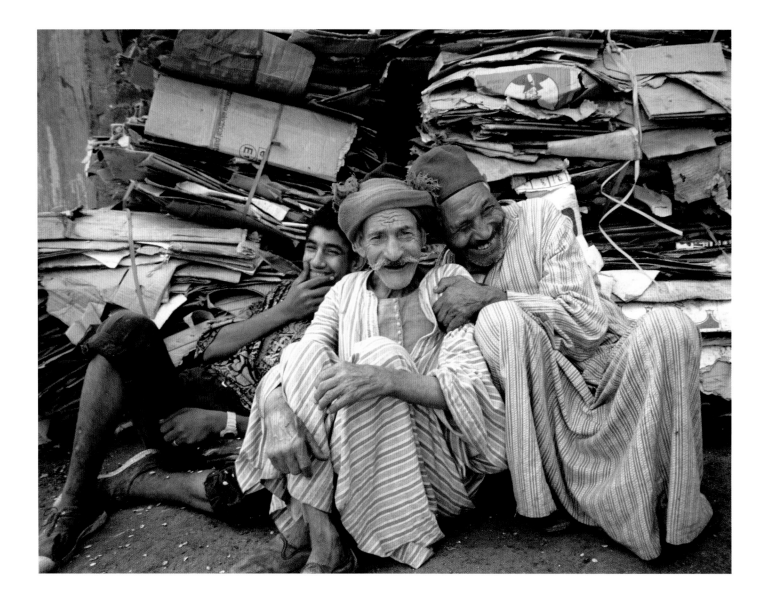

## Zabaleen in Mokattam

It is a warm spring day. Walking the streets in the Mokattam Hills where the *zabaleen* or garbage collectors of Cairo live, I spot these men, perhaps three generations of one family, relaxing. The neatly stacked cardboard behind them will be sold to generate income for their families, some of the poorest in Cairo. Rickety donkey carts driven by men and boys from this area bring garbage to be recycled.

The smell of garbage hangs heavy in the air; pigs, chickens, and mangy dogs wander the garbage-filled streets at will, and the sharp cries of babies and young children are heard everywhere. The wives and daughters sort most of the garbage collected by the *zabaleen*.

I talk with a woman while she sorts garbage collected in her family's donkey cart. Her baby sits in the midst of the garbage. Nearby, two young boys smile at me while leaning against bags of garbage in their father's cart. I smile back, but hold my breath because of the intense smell of rotting food, while brushing flies from my face, arms, and legs.

The men and women I encounter seem happy despite their difficult work and living conditions. *I'll never complain about anything again, I think.*

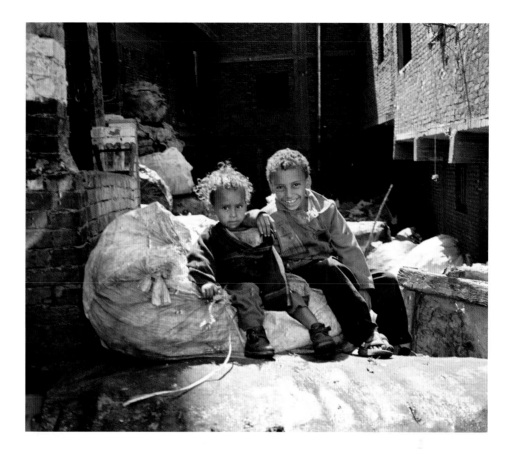

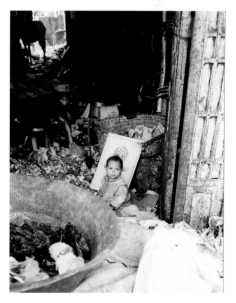

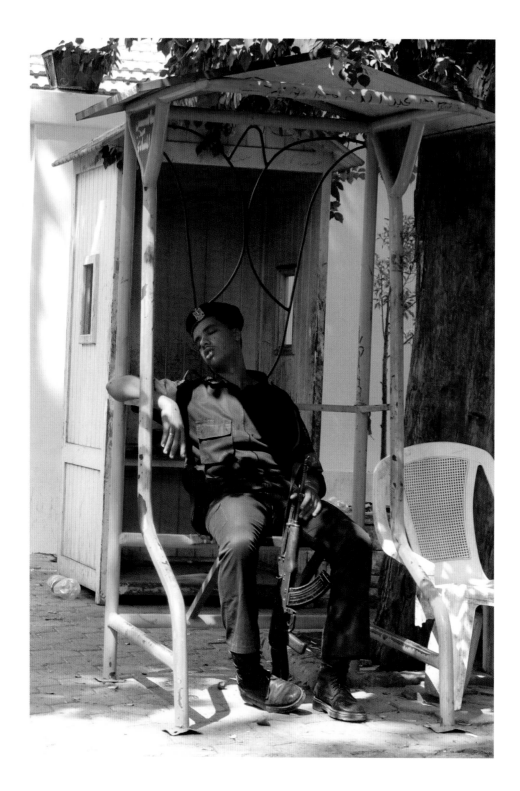

## Sleeping Soldiers

Soldiers perform guard duty throughout Egypt, but are particularly numerous in the major cities. In front of every bank, church, mosque, embassy, hotel, school, mall, and building frequented by expats, young soldiers spend twelve-hour shifts sitting in guard shacks watching for problems that may occur.

They wear black ill-fitting heavy uniforms, carry rifles (no one knows if they are loaded), eat cold food delivered to them, and drink endless cups of tea. It's a boring job for very little pay. I sympathize with these soldiers, who nap while on duty. They're probably nearing the end of a shift where they sat in a guard shack throughout a cold desert night. They're dreaming of warm food and a bed at home!

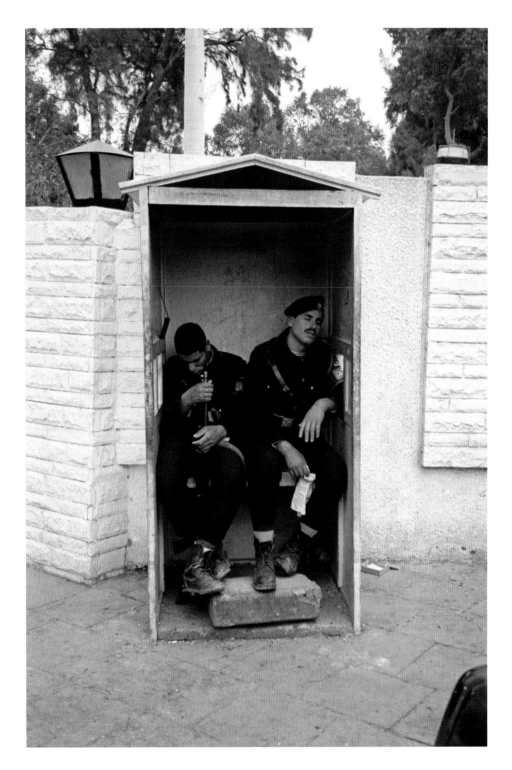

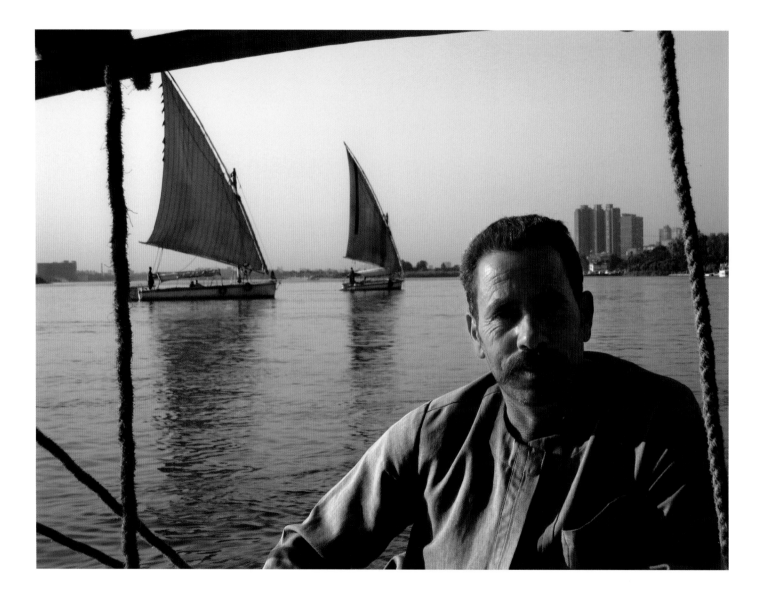

## A Day in Cairo

Mahmoud unties our large flat-bottomed sailboat or *felucca*, gives a hard push, and we are off toward the center of the Nile. After the intensity of a shopping day in the steamy Khan el-Khalili we relax, enjoying the gentle breeze and quiet of the river.

He proudly tells us this boat has been in his family for more than fifty years. He lives with his wife and three young children in a tiny houseboat, fishes for food, and earns money taking Egyptians and expats for rides, often at sunset. Benches topped with colorful woven mats line the sides of his twelve-foot-wide boat. We enjoy Omar Khayyam wine while eating falafel and stuffed grape leaves. The only sounds are the creaking of the wooden rudder and Egyptian music drifting from a boat in the distance. Peace and relaxation permeate our group.

I sigh as Mahmoud turns the sail and we head for home. We tie up to another *felucca*, carefully maneuver our way across the bows of the boats, and climb sixteen darkened steps, returning to the bustle of the Corniche. The spell is broken, yet I smile as I spot a familiar Cairo sight—two women carrying huge metal pans on their heads.

*"Mumkin soorah?"* May I take your picture? I ask as I catch up to them. They turn, smile, and nod yes. I quickly take a shot. A man walking ahead, perhaps the husband of one of them, hears my request, turns, scowls, shakes his bony finger and hisses "No!" to me. He then yells something in Arabic to the women.

I walk along with them. One woman is carrying butter, and the other, the soft white Egyptian cheese I love to eat with pita bread. They will sell it at the local market the next morning. *How does she carry such an enormous weight so far?* I wonder. The man carries nothing.

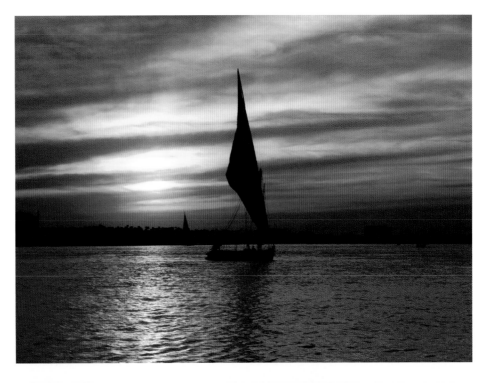

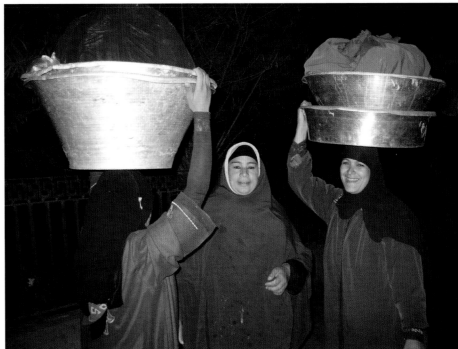

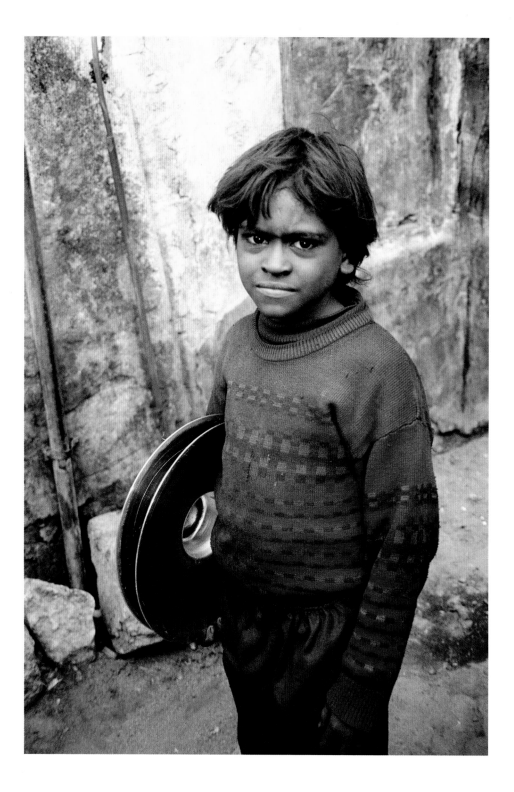

## Aluminum Boys

The City of the Dead is an area of Cairo filled with tombs, mausoleums, and mosques, many dating from the fifteenth century. During the Mameluke period it became the burial ground outside the city walls for sultans as well as ordinary people. In the twentieth century, Cairo's rapid population growth led people to take up residence in some of the tombs. A typical tomb contains a visitor's room that the new residents use as their living quarters. Today these cemeteries contain a mixture of tombs and homes where the living and dead exist side by side. There are paved roads, apartment buildings, small stores, and workshops throughout the area.

When walking in the northern section, I poke my head into a workshop near the Qait Bey Mosque, and find several men polishing aluminum pots at primitive machines. Three small boys about seven to ten years old are busy collecting newly polished pots, delivering tea to the "polishers," or sweeping the floor.

The faces and hands of the workers and boys are darkened with soot created from the polishing machines. One boy willingly smiles for my camera as he delivers a newly polished pan to a storeroom just outside the shop. His teeth and the shiny pan contrast with his soot-covered face, neck, and hands.

I return in a week with pictures for the boys and workers. A small, intense boy, serious beyond his years, carefully tucks his picture and a pencil I give him into a pocket beneath his grimy sweater. His eyes express pain, loneliness, and even helplessness. These boys don't attend school; their lives will probably be spent in this small workshop. It pains me to know that everyone in the shop could be headed for an early death, their lungs coated with aluminum dust.

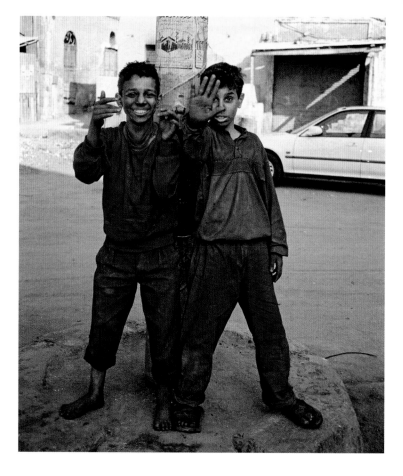

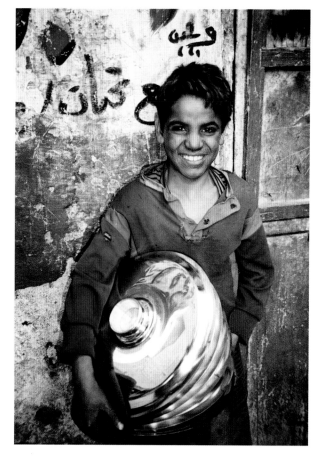

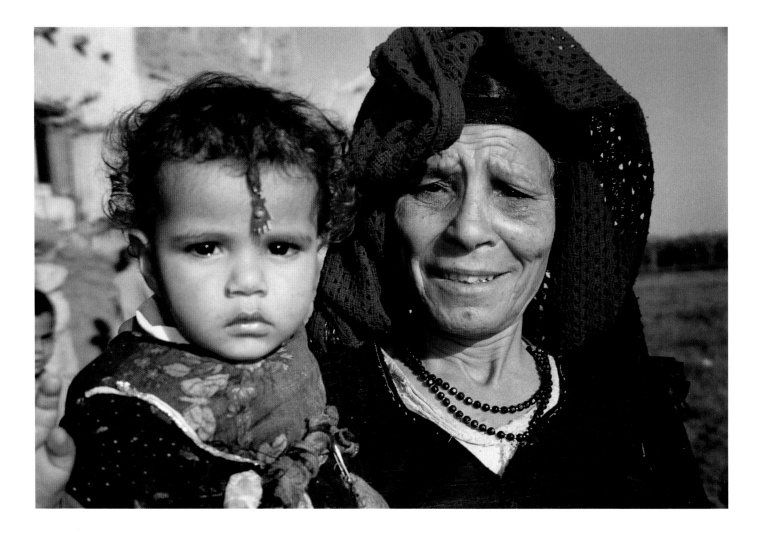

## Life on Gold Island

I climb down the steep bank to the edge of the Nile at a point between Cairo and its southern suburb Maadi, and look across at Gold Island in the middle of the river, with its rustic farmhouses and green fields. A huge public *felucca* with people from the island draws near. It beaches and women get out, carefully balancing huge piles of greens, containers of milk, or pans of cheese on their heads.

Boarding the ferry, I give 25 piasters, about $0.10, to the captain, and sit on a wide seat next to a woman managing three squirming children. The captain sets the square lateen sail and we head toward the island. After about five minutes, I climb out and begin to explore the island.

Two young boys appear, and walk beside me along a narrow mud path between fields planted with tomatoes, peppers, cucumbers, and field greens. We come to an area with several mud-brick farmhouses. At least six young boys are playing soccer in a dirt courtyard with a ball whose leather cover is completely worn off. A woman with a young child comes out to greet me.

*Her daughter? Her granddaughter?* I ask myself. It's hard to tell. I hope the Hand of Fatima resting on the girl's forehead and tightly tied into her curly hair will ward off the evil spirits as it's supposed to. I turn and spot a barefoot girl leaning against the courtyard wall. She stares at me intently. Flies rest on her cheek and others circle near her. She doesn't smile or acknowledge my greeting.

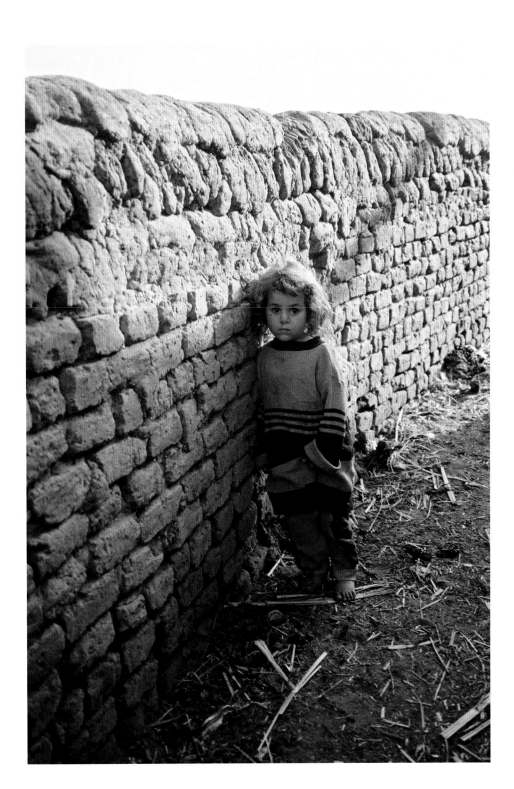

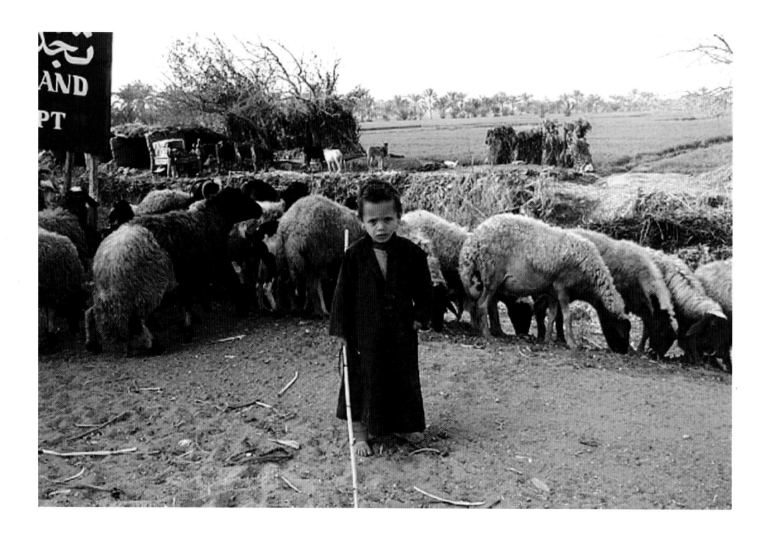

Faces of Egypt

## Boys with Sheep

The Saqqara area, with its rich green fields, rows of date-palm trees, and quaint villages, differs radically from nearby Cairo.

I walk along a road and spot a handsome boy on a donkey carrying a sheep in front of him. *Is the sheep sick or is it dead?* I think. The boy and I smile at each other and he continues along his way.

Further along the road I spot a young boy watching a herd of sheep. *"Ismi Ahmed,"* my name is Ahmed, this barefoot boy of five in a patched *galabeya* tells me as he tends his family's flock. Ahmed corrals them gently with his bamboo stick, calling some by name.

It pains me that he has no childhood. *Will he ever learn to read and write? Will he get decent health care? Where does he sleep on these cold January nights? Life isn't fair,* I think.

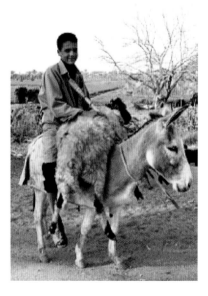

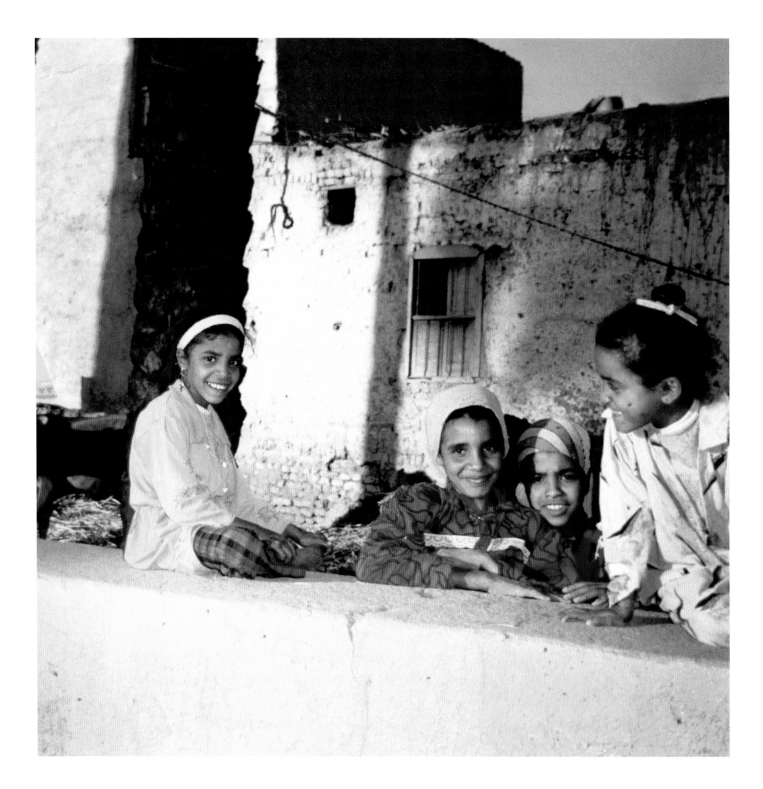

## A Village near Luxor

We travel with a group to a small isolated village near Luxor. We are led by a knowledgeable American Egyptologist from Chicago House in Luxor who will show us a little-known and seldom-visited Pharaonic temple within the village boundaries.

With a chanting lilt in his voice, our guide translates the hieroglyphs etched on the temple walls and pillars. As he reads the ancient texts, he seems happy to be drawn back to artifacts from Eighteenth-Dynasty Egypt.

Despite his melodious readings, I'm drawn to the local people living in this tiny village. Four young girls peer at us over a nearby mud-brick wall. I sneak away from the group to get a shot of their smiling faces peeking through the dried stalks of sugar cane that are part of the wall. Further along the perimeter of the ancient temple, I spot four more girls with a family cow. They are also watching us in the glow of the late afternoon sunlight. I marvel at the joy in their beautiful smiles.

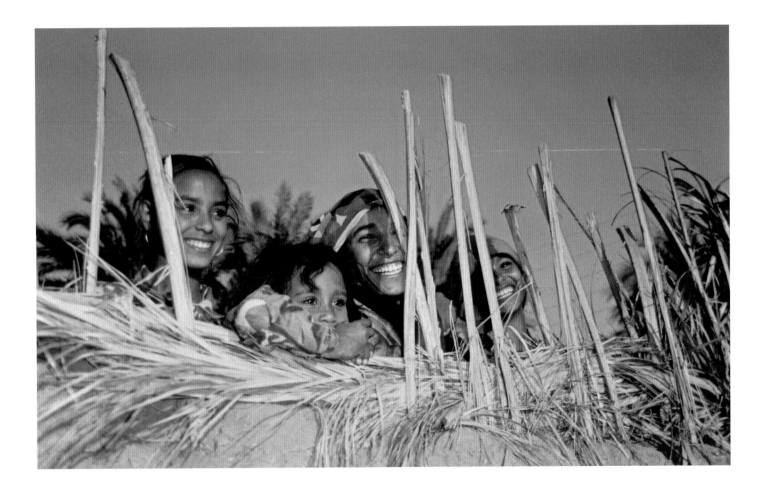

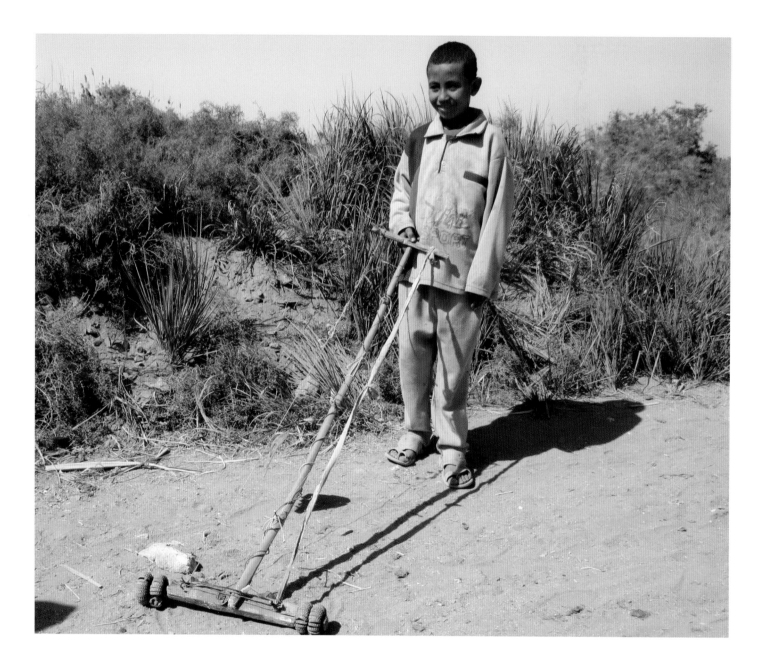

## A Boy and his Lawnmower

Minya in Middle Egypt contains a treasure trove of Pharaonic and early Christian historic sites. Many still need to be fully explored and documented.

We tramp through fields of broken artifacts, Corinthian capitals, and parts of pillars from an early-fifth-century basilica constructed over a Pharaonic temple of Ptolemy. While touring the area I spot a young boy pushing what looks like a toy lawn mower. He smiles and proudly shows me his handmade toy. I marvel at the creativity: wheels made of bottle caps carefully strung together and attached to a piece of old wood, with a handle cut from a bamboo stalk.

Nearby, a dirt path used by people in the area cuts through the field of artifacts. Four women in black coming back from the local market hurry by. Despite their heavy loads, they pause and smile for my camera.

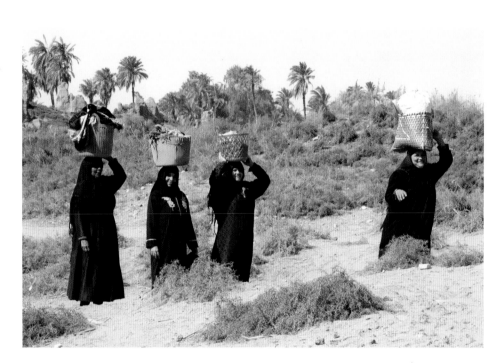

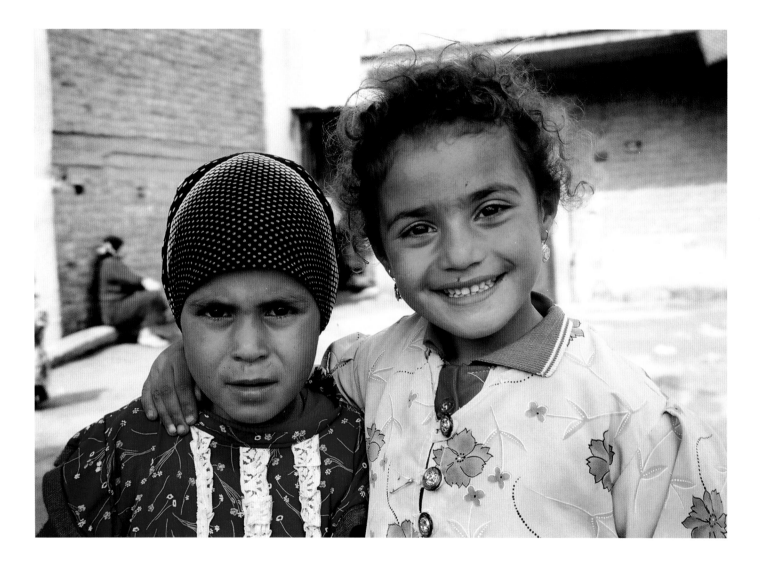

## Children of Fayoum Oasis

The huge wooden waterwheels in the Fayoum Oasis are ancient. Since the third century CE, more than 200 waterwheels have constantly moved water from one canal level to another to irrigate the rich fields of the oasis. We walk in a small village to see these amazing waterwheels in action.

Along the way, children gather to watch "the foreigners." I see one little boy of about two peek out at us curiously. Another boy with huge brown eyes, wearing a striped *galabeya* and shiny red shoes, stares at us from atop his father's donkey cart. Two young girls, one covered, even at this early age, smile for a picture. We reach the waterwheels and two more jump quickly in front of the rapidly turning wheel to pose proudly before the village landmark.

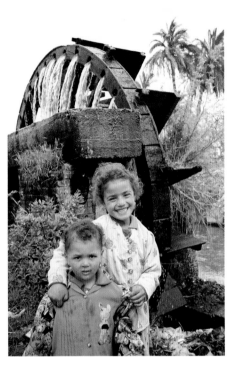

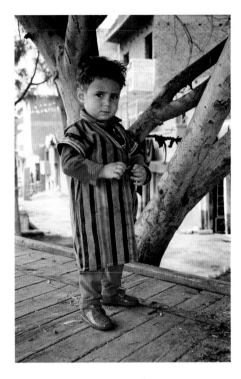

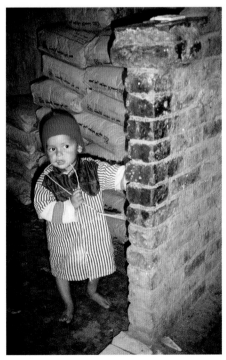

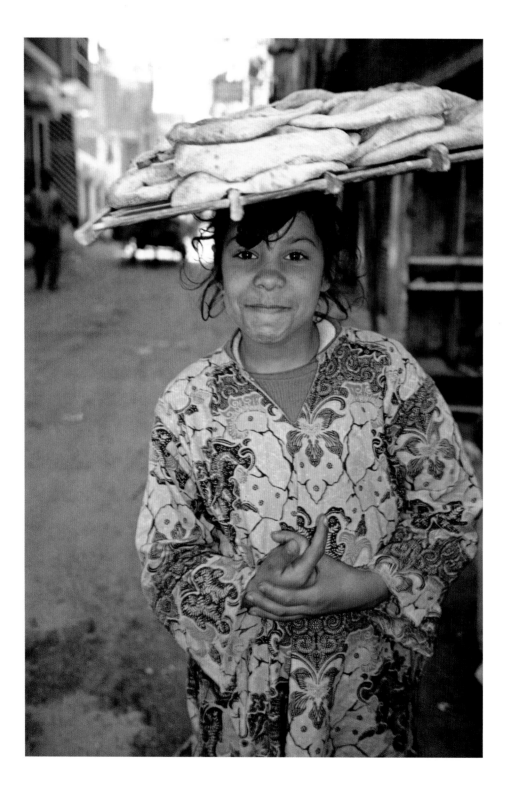

## Bread

Bread *(ayeesh)* and rice are the staple of every Egyptian meal. Boys on bicycles, balancing stacks of freshly baked flat bread, negotiate Cairo's crowded streets to deliver their precious cargo to street vendors. Cairo's "trapeze artists," they're called.

In the poorest neighborhoods subsidized bread is available at government shops. Anxious women elbow their way to the head of the pack at the bread window. They wave two crumpled Egyptian pounds and emerge from the crowd with ten loaves of nutritious wheat pita bread, dinner for their five or six young children.

Sometimes young girls, like the sweet girl in the print outfit, wait in the crowd near the window and carry bread home to their families. The two boys probably plan to take their bread to a street corner deep in their neighborhood and sit patiently for most of the day to earn a few pounds selling it.

This man in the lower right photograph "owns" a street corner in the *zabaleen* area of the Mokattam Hills. He talks with me while he hawks his bread. His toothless smile is infectious! I smell the warm bread and dream of spreading it with hummus that night. I buy three loaves and head for home.

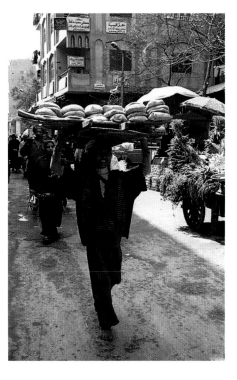

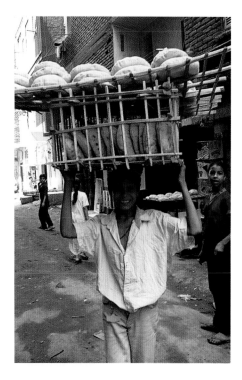

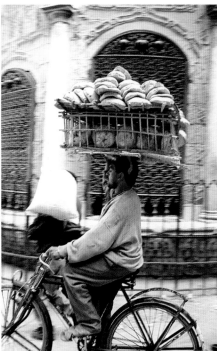

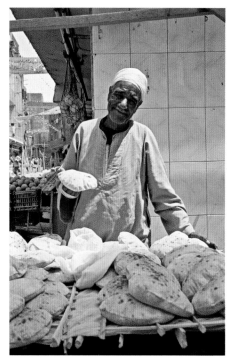

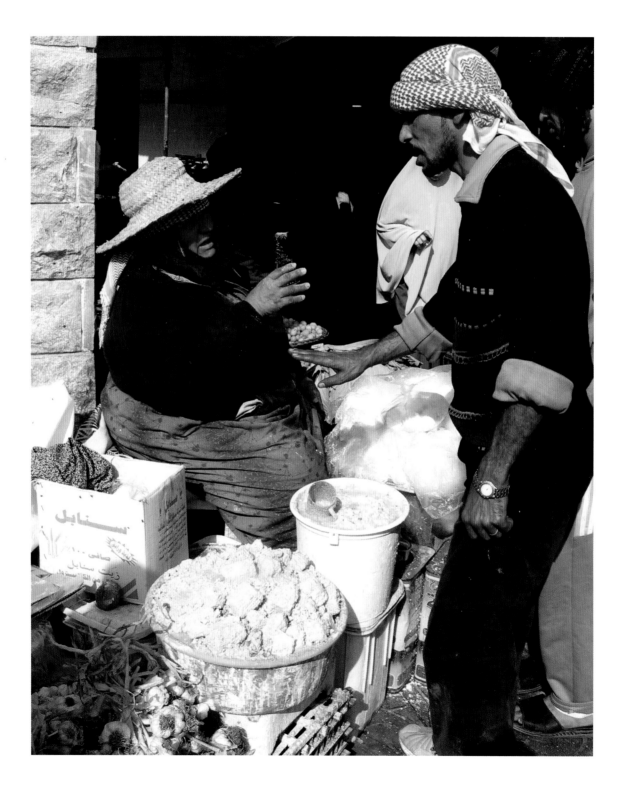

## Goat Cheese for Sale

Fresh white goat cheese is found in every market throughout Egypt. This woman made her huge pan of fresh cheese from the milk of her family's goats. She bargains with the man in the red *keffiyeh* over the price of two kilos of her homemade cheese. Bargaining over the final price is expected with every transaction in Egypt.

After three or four minutes of haggling, they agree on a price, and the man leaves with his cheese tied up in a plastic bag. The woman adjusts her hat for the sun, brushes a fly from her face, leans back, and hopes for another customer.

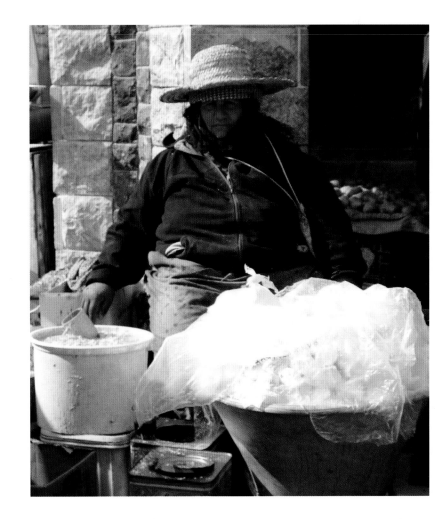

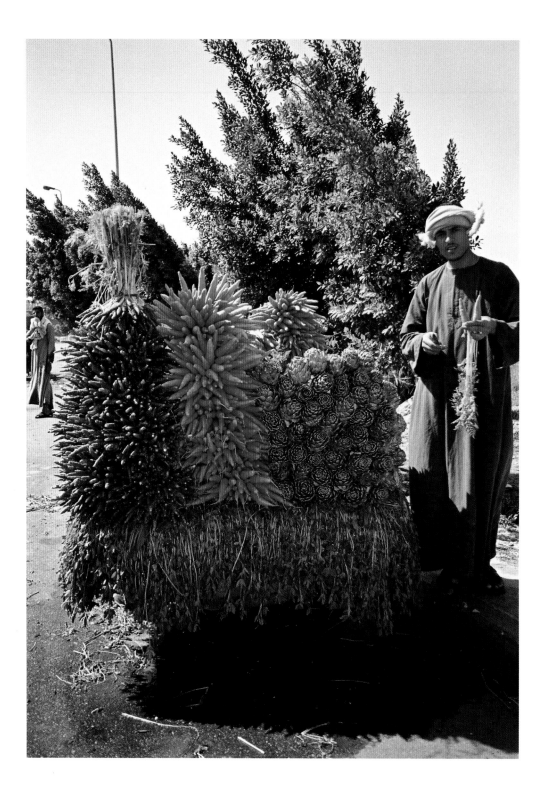

## Fruits and Vegetables for Sale in Cairo

The greengrocers of Egypt are artists. Small piles of trash litter the streets near their shops, but their own fruits and vegetables glow on display stands or carts like works of art. They stack apples and oranges in perfect pyramid shapes.

Another farmer arranges his orange and purple carrots and fresh artichokes to entice those who walk or drive by. Carrot greens are draped along the perimeter of his cart to set off his colorful vegetables. He picks out several carrots and four huge artichokes, weighs them on an old metal scale, and softly murmurs *"Shukran,"* thank you, as he hands them to me.

Bright red tomatoes and fresh eggplant displayed on a market street in Old Cairo attract women shopping for their evening meal. They are totally focused as they carefully select, weigh, and bag their purchases. I can almost smell the moussaka, with its tasty béchamel sauce, that women often prepare with these vegetables.

On a nearby street a young boy offers lemons, limes, and garlic for sale in huge hand-woven baskets. He'll sit there all day helping to augment his family's income. *"Ismi Mahmoud,"* My name is Mahmoud, he answers my question with a wide grin. "You can buy one kilo of lemons and limes for just two Egyptian pounds," he pleads. Who could resist his wares or his smile?

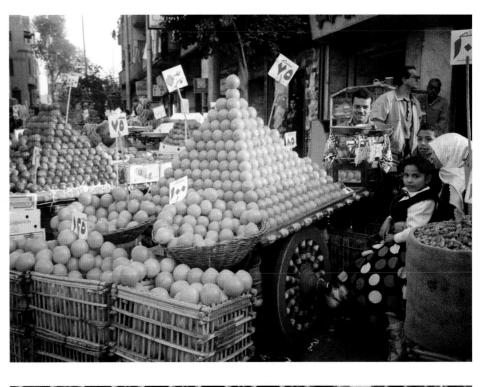

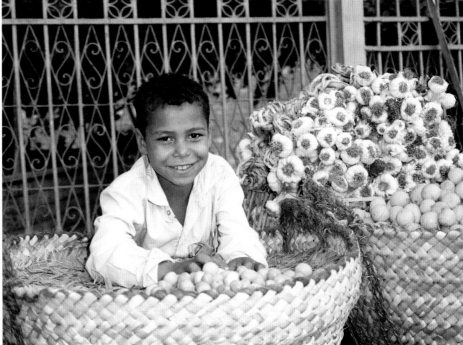

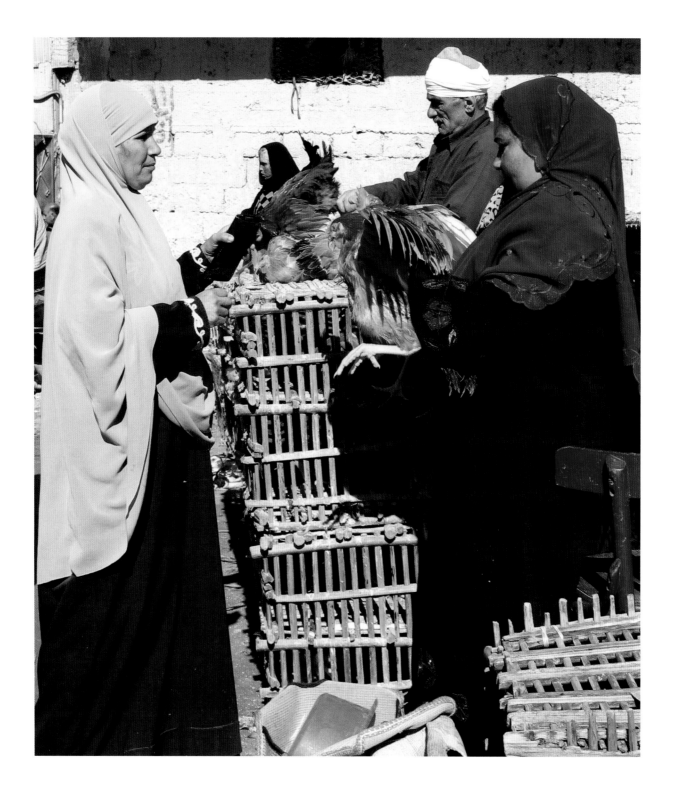

## Thursday Market in Al-Arish

It is market day in al-Arish. The woman on the left is buying a chicken for a special family dinner that night. She holds a live squirming chicken in each hand to test their weight. She gives her selection to the woman in blue. The chicken is then passed to the man in grey, who gives the chicken's neck a quick hard twist to kill it, and places the dead bird in a plastic bag for its final trip home to be part of the evening celebration. You never worry about freshness when you buy your chicken in this market.

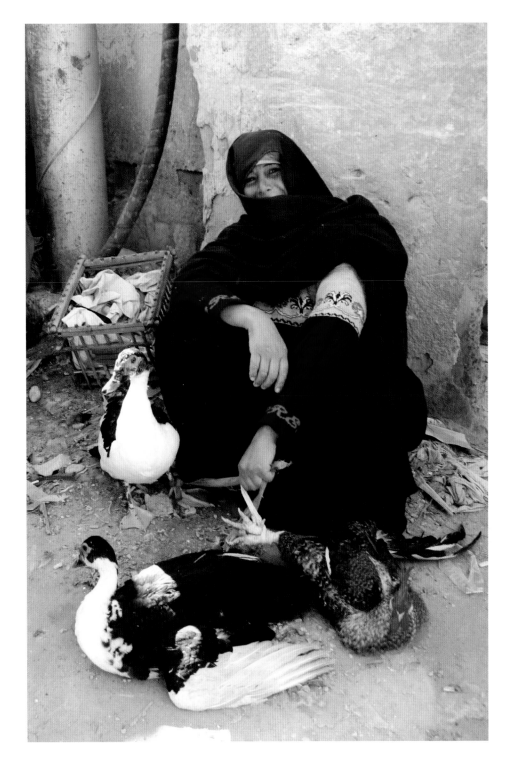

Food

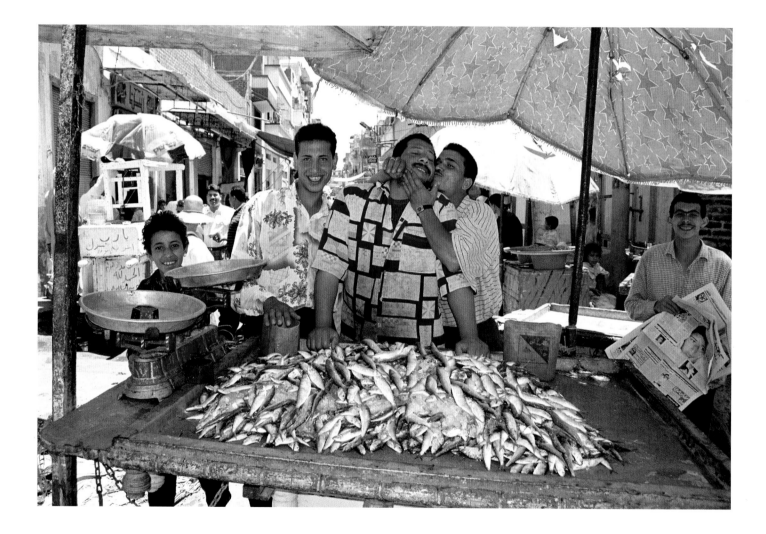

Faces of Egypt

## Fishing in Egypt

Egyptians love to eat fish, especially during the feast days following Ramadan. Fishermen or women with makeshift poles and nets are often seen fishing from small boats along the Nile.

Larger boats fish off the Mediterranean coast in the north and in the Red Sea to the east. Street vendors display their fish for sale from carts or tables along the streets in cities and villages. It's always good to check the eyes of the fish to make sure they are perfectly clear before buying them.

The boys on the left, from Rashid in northern Egypt, clown for my camera while selling their fish, freshly caught from the Mediterranean.

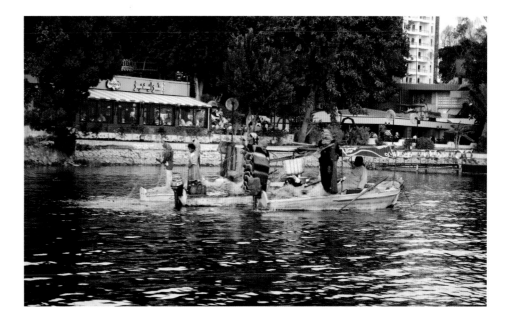

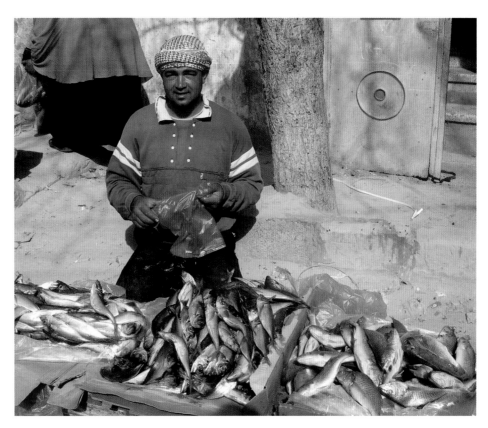

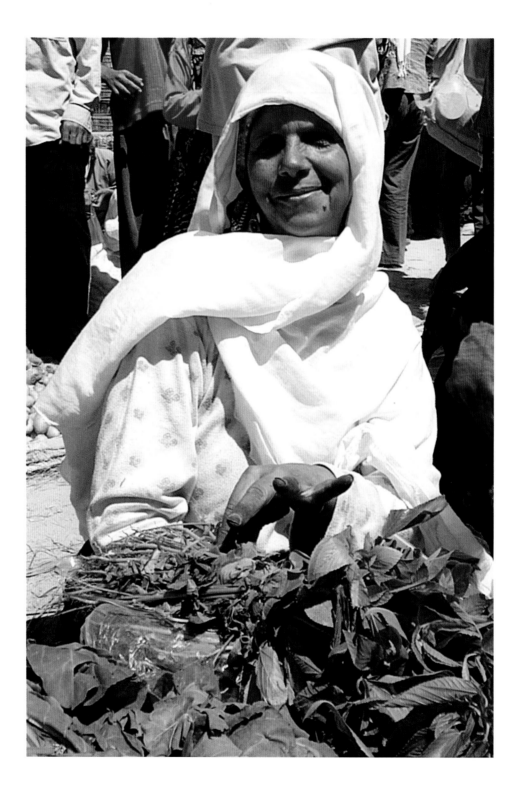

## Market Day, El Gorah

Every Egyptian town has its market day. It's a time for families in the area to sell their produce and purchase things for their homes. Women particularly look forward to a time of socializing.

El Gorah, about 10 kilometers from the Rafah crossing into Gaza, is a tiny town with one main crossroad. It's fun to visit their Wednesday market and walk by colorful displays of fruits and vegetables, fresh from the nearly fields. Enormous piles of bright red tomatoes beckon me.

Further on, I smell fresh greens, *gargora,* think of the wonderful salad they will make, and ask to buy two bunches.

"You can have them for free because you're new to the market," says this smiling woman. "This is a *hiddeyaa,* a present, for you."

I take the greens, knowing it's an insult to refuse a gift, but press a tightly folded twenty-pound note into her hand.

*"Fi aulaadik,"* for your children, I say. We smile at each other; we are both happy.

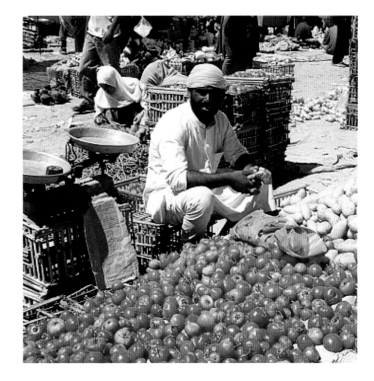

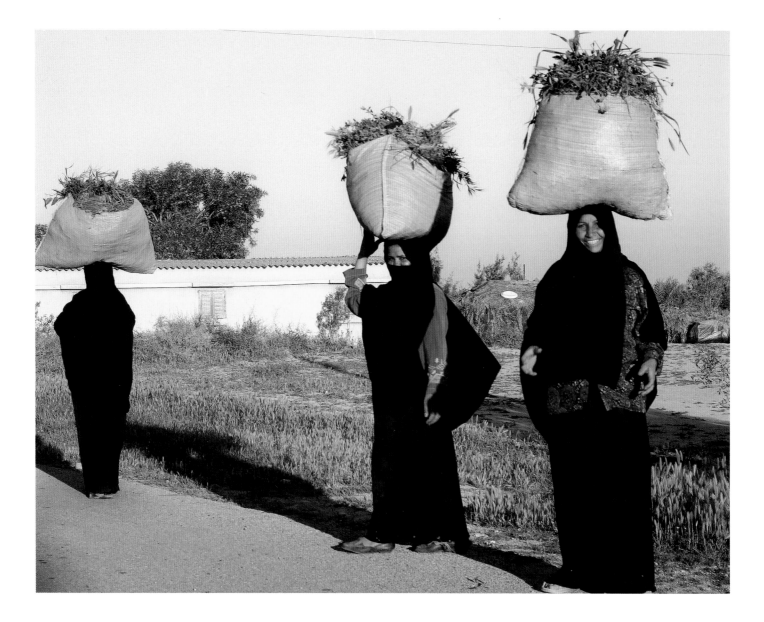

## Women Carrying Things

From the time they are young, girls throughout Egypt learn to carry things on their heads. By the time a girl is twenty, the weight and distance she hauls her load vastly increase.

The three Bedouin women walk to their homes with twenty-kilo packs of greens to feed the family goats. They would have spent the morning cutting the greens in a distant field. Another Bedouin woman gathers sticks for firewood to cook her family's dinner.

The woman in red lives on Gold Island in the middle of the Nile near Cairo. Her enormous aluminum pot is filled with milk. She will take a *felucca* across the Nile and balance the heavy container on her head as she delivers it to a market in Old Cairo.

Another woman is carrying a heavy iron butagas stove on her head as she walks with her son in the City of the Dead. She might be taking it to a friend's house where they'll cook dinner. Finally, two live turkeys are perched in the basket atop a woman's head. They will probably be kept in her yard before being served on a special feast day. I admire the strong work ethic of these women.

*Do they ache after their backbreaking work? Could I work as they do?* I ask myself.

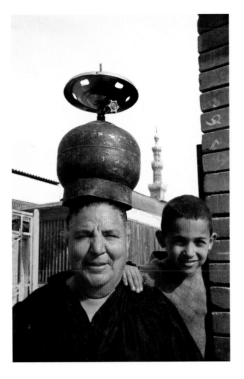

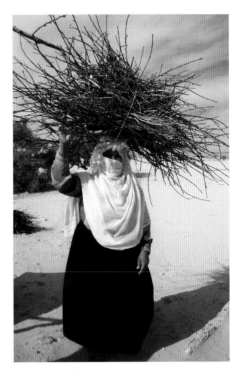

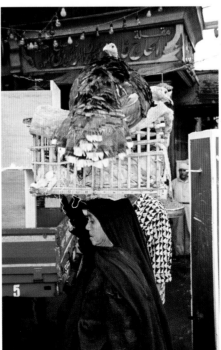

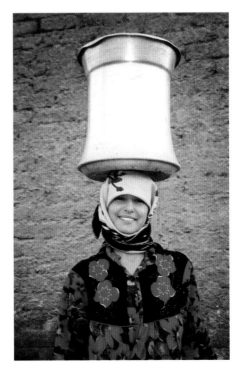

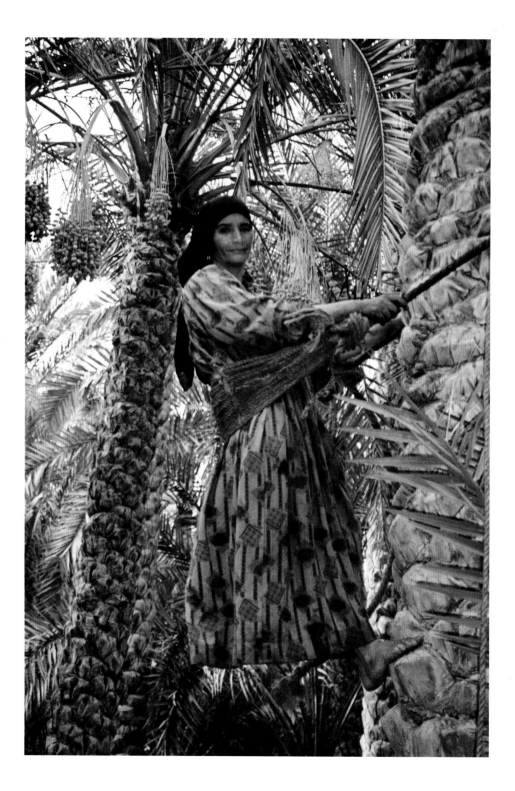

## Harvesting Dates

Dates are harvested in the fall throughout Egypt. In Saqqara they grow in abundance.

I am amazed to see a woman climb a forty-foot date palm in a matter of seconds. Barefoot, she circles her waist with a heavy rope and clambers up the tree, hooking the rope to the bark above her as she moves higher.

Nearing the top of the tree, she shifts the large basket at her side to the front, reaches out toward the hanging dates and shakes them into the basket. I hold my breath as I watch her. When her basket is loaded with dates, she maneuvers down the tree while balancing the heavy load at her side. She lets me taste some of the fresh dates, and to this day I still salivate thinking of that moment.

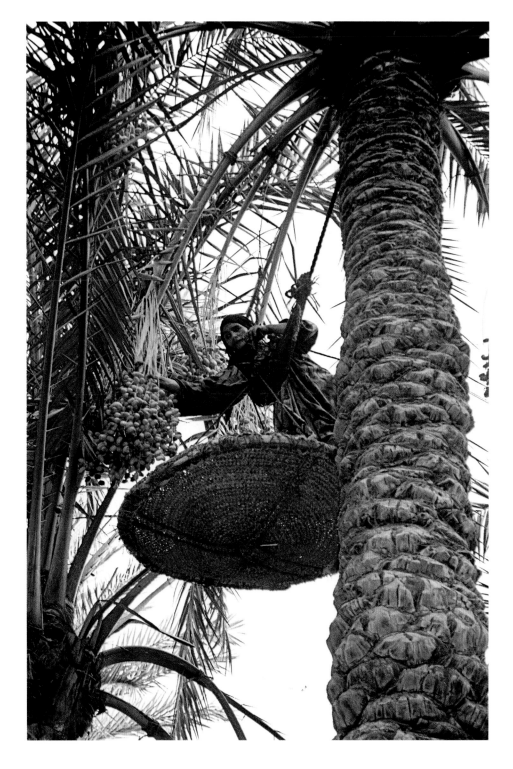

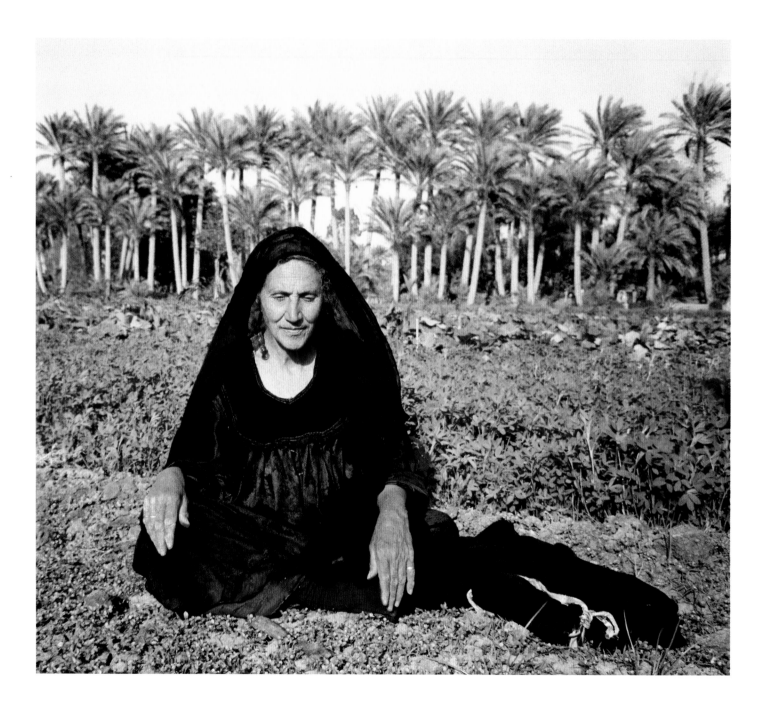

## Woman Weeding

We drive past the green fields of Giza,
admiring the pyramids in the distance,
and head toward the farmlands of Saqqara.

Tramping along the edge of a field of
greens in the Saqqara region, I see a
woman in black weeding. I squat beside
her and we talk about our children, the
warmth of the day, and the age of our
husbands. Before I take her picture, she
carefully removes one black headscarf,
adjusts the other and tries to rearrange
her hair.

I marvel at her large hands, soiled from
her day's work, and examine her long
gnarled fingers. Women the world over
work intensely with their hands and seem
to always primp before their photograph
is taken.

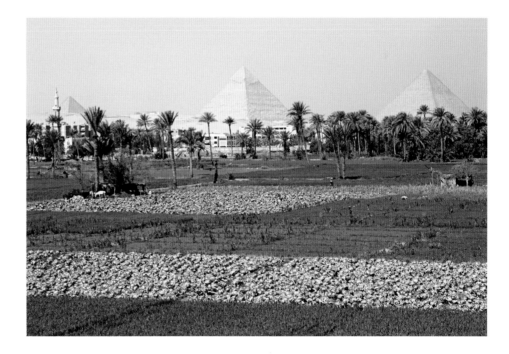

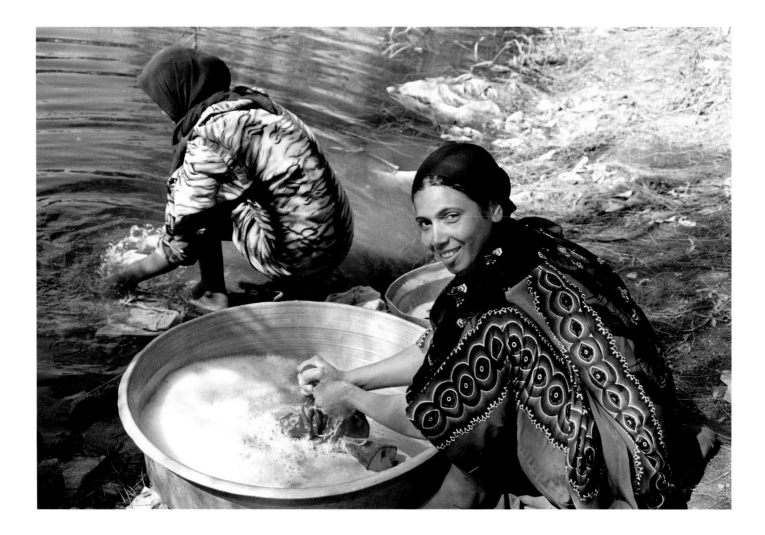

## Washing Clothes

"This is the way we wash our clothes so early in the morning" goes the children's nursery rhyme. In Egypt clothes-washing takes many forms. On Zamalek, the island in central Cairo, a young boy bikes to our apartment building and climbs six flights of stairs to pick up my husband's shirts.

He returns them the next day, carrying Jud's beautifully washed and ironed shirts over his shoulder while navigating the crowded streets on his bike. No receipts needed! We never know where he takes them, or how they are washed, but he always returns, and we never lose a shirt.

In many of the villages, women wash the family clothing outside and hang it on bushes or lines strung between trees. Other women trek to the Nile carrying the laundry in a large metal pan on their heads. They scrub and rinse the clothes on rocks in the polluted water, hang it to dry on nearby bushes or carry the heavy wet load home to hang from their window to dry.

These two young girls carry their laundry to one of the canals in Giza along the road to Saqqara. They hum as they squat and wash in the murky water. I slide down the bank toward them and watch as they scrub each piece with a bar of homemade soap.

I'm temporarily distracted by the braying of a donkey who's being whipped and pulled down the bank to the water upstream so his owner can wash him. Banana and lemon peels and other garbage float along as the girls continue their work. They smile and nod consent for me to take their picture. After doing this backbreaking work they will walk home, hang up their heavy load, and continue with other chores until sundown.

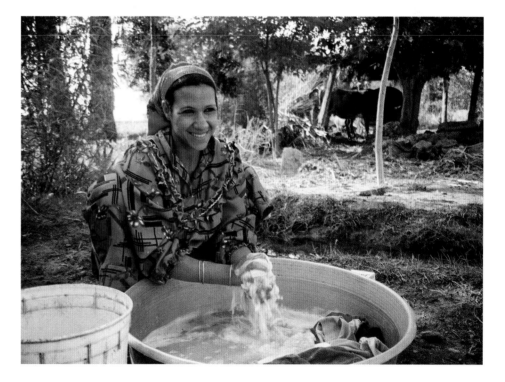

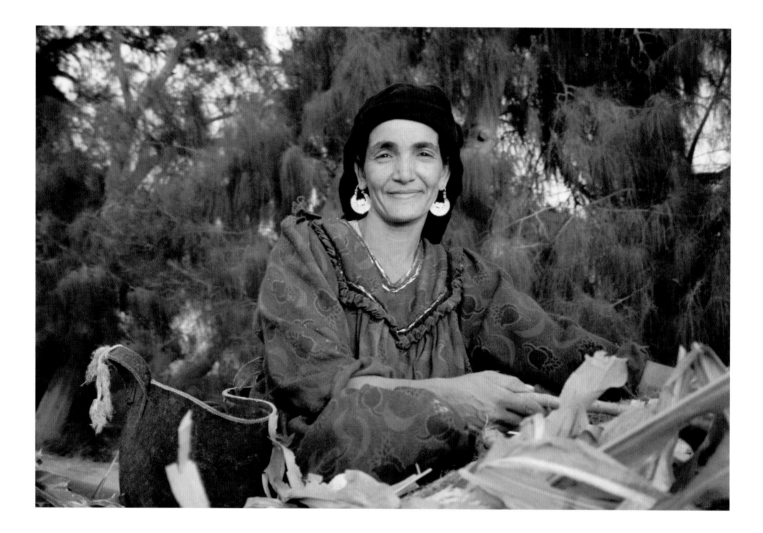

## Palm Fronds and Earrings

It's five o'clock on a fall afternoon. I walk along a rutted dirt road on the outskirts of a small village beyond the Pyramids of Giza. The golden glow of the setting sun threads through palm and pine trees along the road. I spot a donkey cart in the distance; its wooden wheels creak as it nears.

The cart is piled high with dried fronds collected from the palm trees in this area. Many products are gathered from these trees, among them fresh dates that are part of many Egyptian meals, and palm oil used for making soap. I can almost smell the date-and-nut bread I will make from the fresh dates. The fronds are woven into baskets and mats that are found in Egyptian homes. Fronds are also used to construct huts or covered areas adjacent to homes known as hooches, which serve as reception areas for visitors.

A pleasant-looking woman drives the loaded cart. As she nears, I wave; she slows her cart to a stop and returns my smile. In her cart I notice a black basket (*makhtof*) made from discarded tires. It's filled with several knives, one with a huge curved blade, and plastic containers with the remnants of her lunch. The sun reflects off her large gold earrings. Without a hint of make-up her eyes twinkle and her skin is smooth and fresh-looking.

"I've been climbing trees to cut these fronds since early morning," she tells me. "I'm on my way home to cook rice and lentil soup for my husband and children."

"You must be tired," I say in Arabic, but she shakes her head and her earrings almost dance in the fading sun.

I wish her well; we are both pleased with our brief encounter. I wave, and continue wending my way along the road. She gives her bedraggled donkey a soft tap with the reins. The scraping of the wheels and braying of the donkey accompany her as she heads for home.

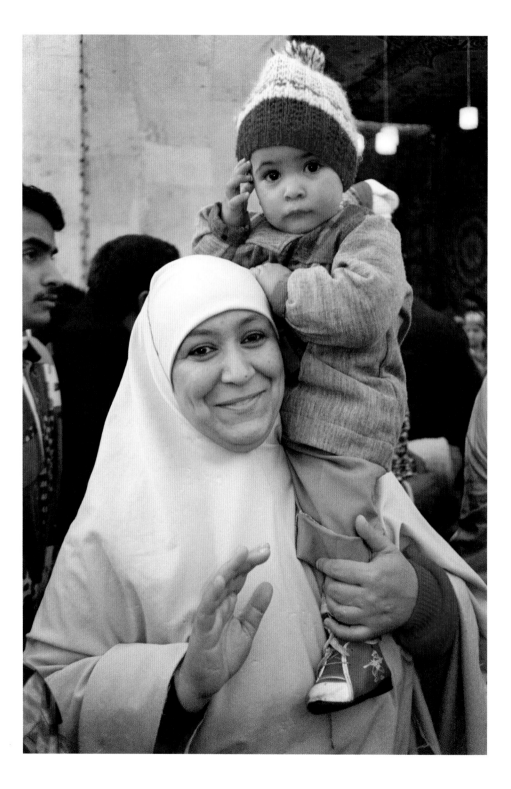

## Carrying Babies

In many African and South American countries, women strap their young to their backs with colorful cloth sashes. American and European women tend to carry their babies on their hip or facing them in a Baby Bjorn carrier.

Once their children can sit by themselves, Egyptian women hoist their young ones to their shoulders when they go out. From their high perch, these children sit tall and are content while their mother shops, chats with a friend, or even participates in a *moulid,* a birthday celebration for a Muslim saint.

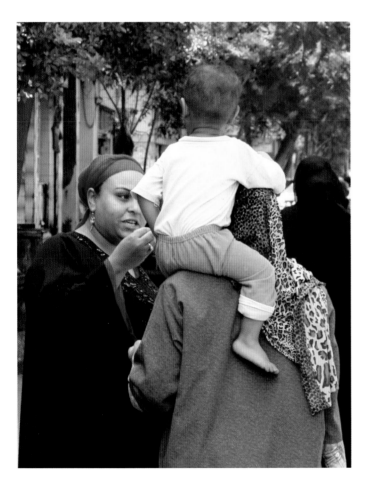 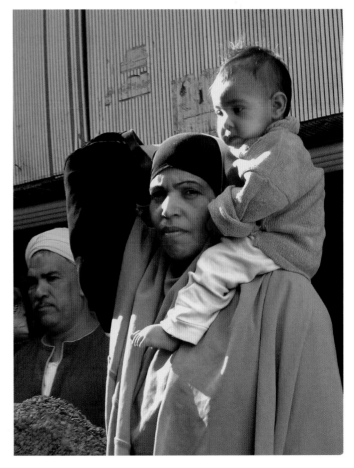

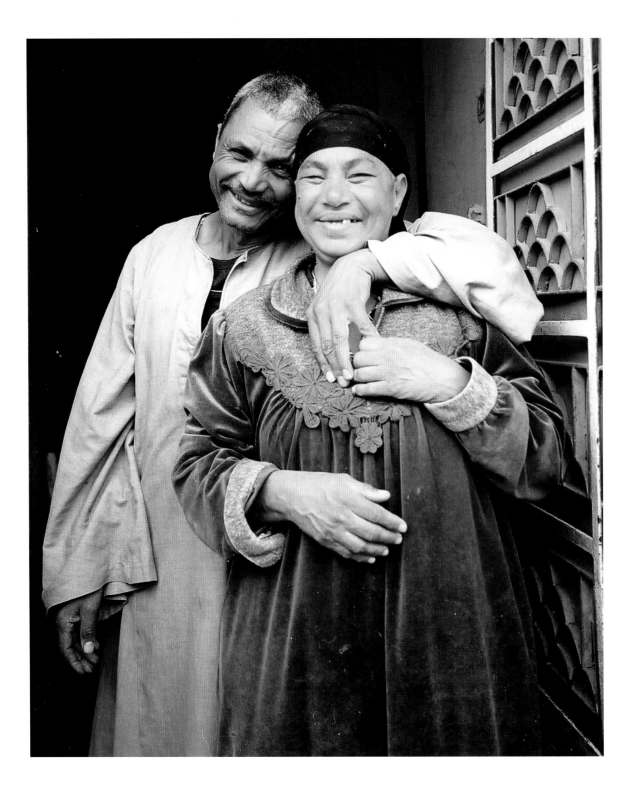

# A Visit to Fayoum Oasis

On a bright March morning I drive slowly through the densely crowded streets of Cairo. Horns honk incessantly and drivers shout out car windows as I carefully ease my car along a narrow lane, cars crowding me on each side. A woman balancing a huge basket of food on her head clutches the hands of two toddlers and weaves her way across the street. The smell of rotting garbage, piled high in a nearby donkey cart driven by a boy who should be in school, fills the air.

As I near the Desert Road, the Pyramid of Khufu looms in the distance. It has dominated the skyline for more than 4,500 years. Making the turn by the Mena House Hotel near the pyramid, I heave a sigh of relief and leave the bustling streets to head south toward the Fayoum Oasis. Soon I am in open country. Flat sandy land, thorny scrub bushes, plastic bags caught in wire fences, and black garbed women watching flocks of goats dominate the view on either side of the road.

As I near the oasis, the scene begins to change. There are palm trees and wide green fields as far as one can see. Men with long *galabeyas* tucked in their belts work the fields. At a small village nearby, ancient wooden waterwheels still rotate, moving water to irrigate the fields.

As I walk down the village street to see the waterwheels, a man and woman appear in the doorway of a cement-block house. Stains from the tabouli salad she is preparing for their lunch dot her dress. The genuine affection they feel for each other radiates from their smiles and the touch of their hands. *They display much more feeling for each other in public than many Egyptians,* I think.

I am reminded of my friend Hussein, who told me that he always walks ahead of his wife when they are in public and he never calls her by name. He either calls her *Om Sayed,* mother of Sayed (their son), or snaps his fingers to get her attention. How different from this happy couple in Fayoum.

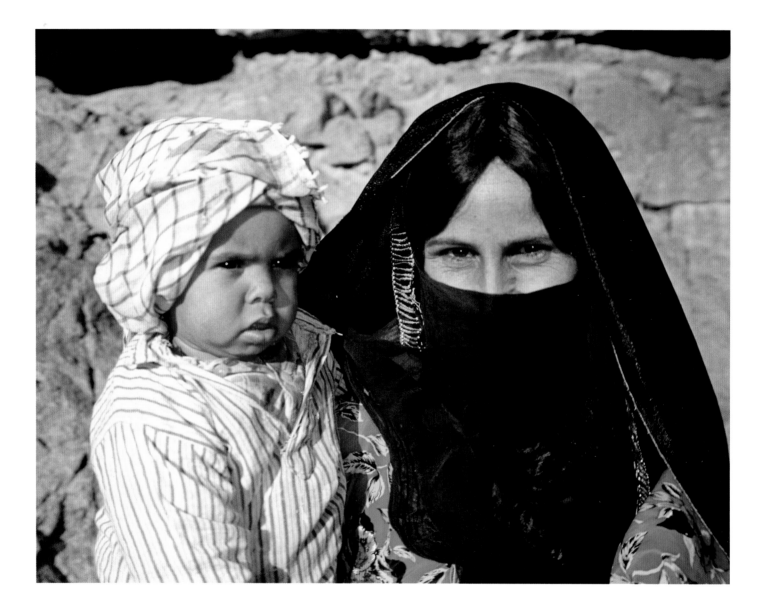

# With their Children

Throughout my travels, photographing mothers and their children fascinates me the most.

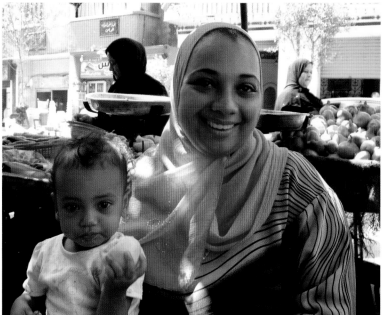

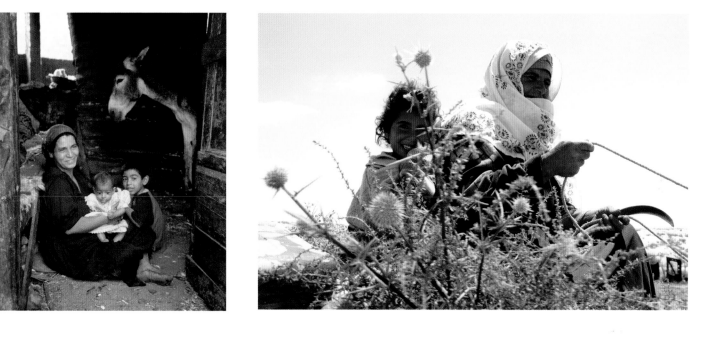

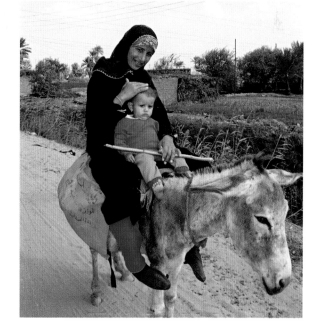

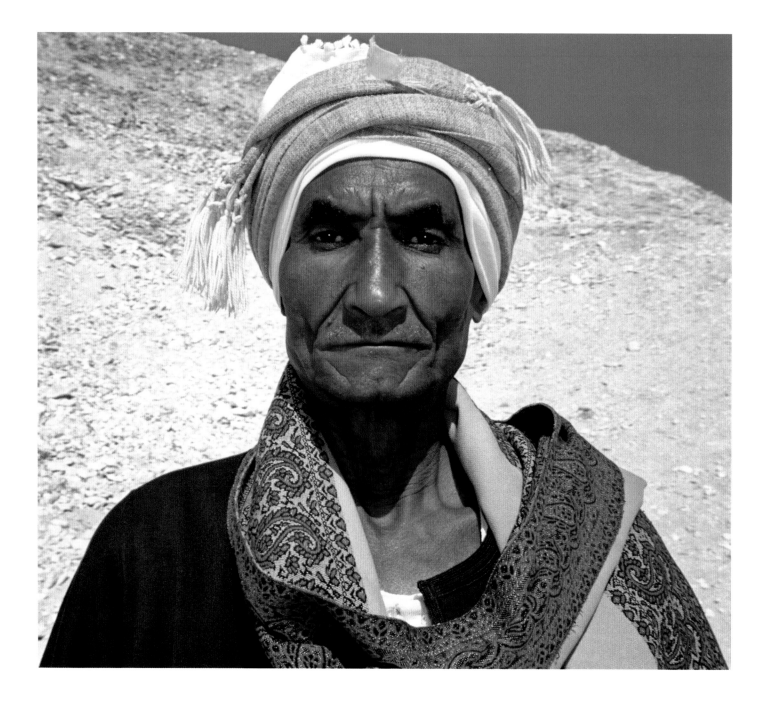

## Guard at the
## Valley of the Kings

Any trip to Egypt should include a visit to the underground tombs in the Valley of the Kings on the west bank at Luxor. During the era of the New Kingdom from 1532 BCE to 1070 BCE, elaborate tombs were built for the Pharaohs in this isolated valley. The walls of these tombs are etched with hieroglyphics of readings from the Book of the Dead and beautifully painted bas-relief scenes of the Pharaoh and Egyptian gods on their journey to the next world.

Just outside these tombs, *boabs,* a term taken from the Arabic word for door, stand guard and protect the tombs. They wear *galabeyas,* and long cotton or wool scarves woven with paisley designs circle their necks. Many of these guards come from families who cherish the opportunity to protect the historic tombs of their ancestors.

This man tells me he's the fourth generation from his family to work in the Valley of the Kings. He stands willingly, yet gives me a stern look while I take his picture. His stance exudes firmness and power, and his dark eyes and straight-set mouth reflect his resolve. I will not violate any rules while he's guarding Ramses VI's tomb!

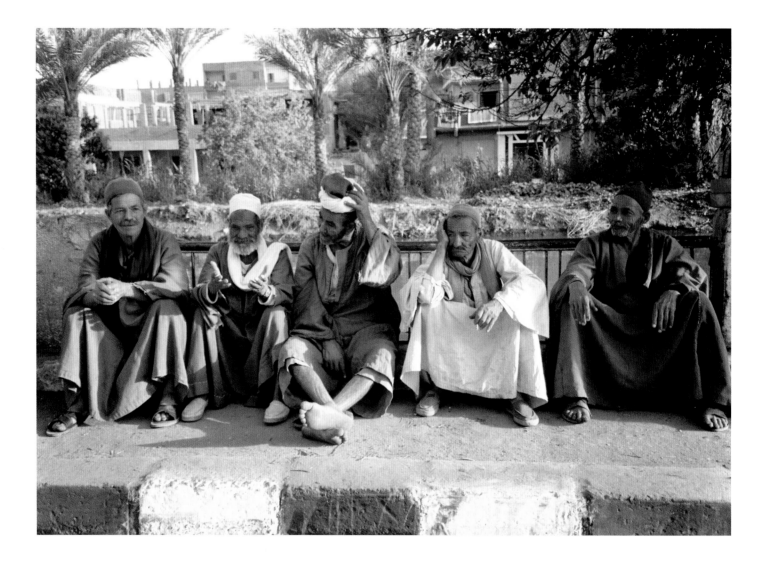

## Men Relaxing

Drive through any city or village, and you will see men relaxing in cafés, sitting near street corners, leaning against buildings, talking intensely, playing dominoes or *sigga,* an ancient board game, slowly drawing on cigarettes, or enjoying a water pipe—all while drinking endless cups of tea.

While driving through a village on the way to the Step Pyramid at Saqqara, I spot five men relaxing as they watch heavily loaded donkey carts, battered taxis, and shiny tour buses on their way to visit the Step Pyramid.

I quickly stop my car, grab my camera, and snap this photo just before the man on the left shakes his finger and yells something at me.

*"Tayyib,"* OK, I say, smile, and get back into my car. The men resume relaxing.

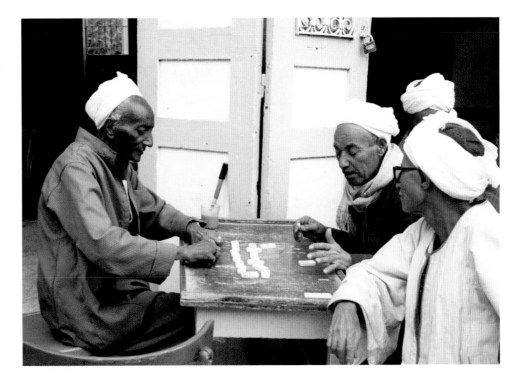

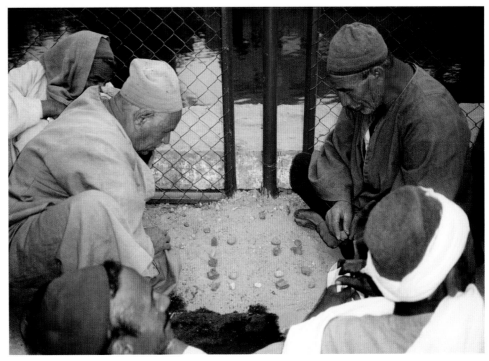

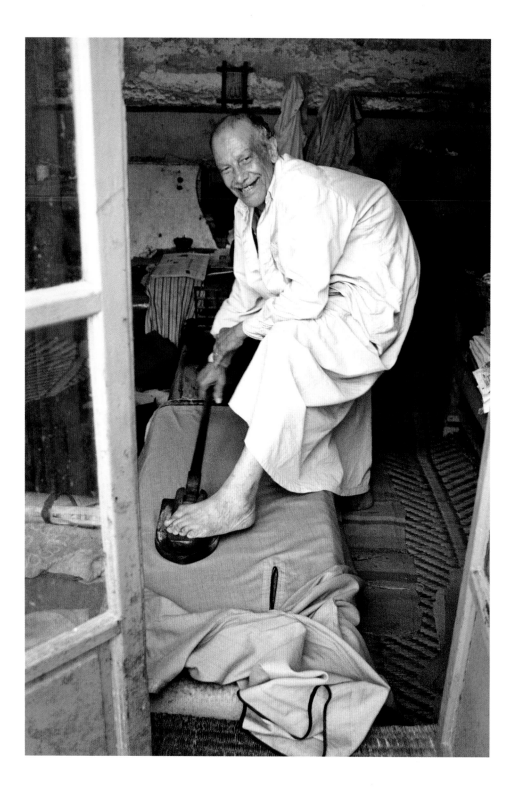

## Ironing Man

Many Egyptian men, particularly the poor from Cairo or the villages, wear long cotton gowns known as *galabeyas*. Most are blue, brown, or grey; others are striped. They are perfect in a warm climate because air circulates beneath them. When a man returns from the Hajj, or pilgrimage to Mecca, he proudly wears a white one with a white crocheted hat to Friday prayers at the mosque.

Many send their *galabeyas* to a *maqwagi,* or ironing man. This engaging man irons the traditional Egyptian way—with his foot—carefully guiding the large iron that is heated in coals burning nearby. Hard work, but always performed with a smile.

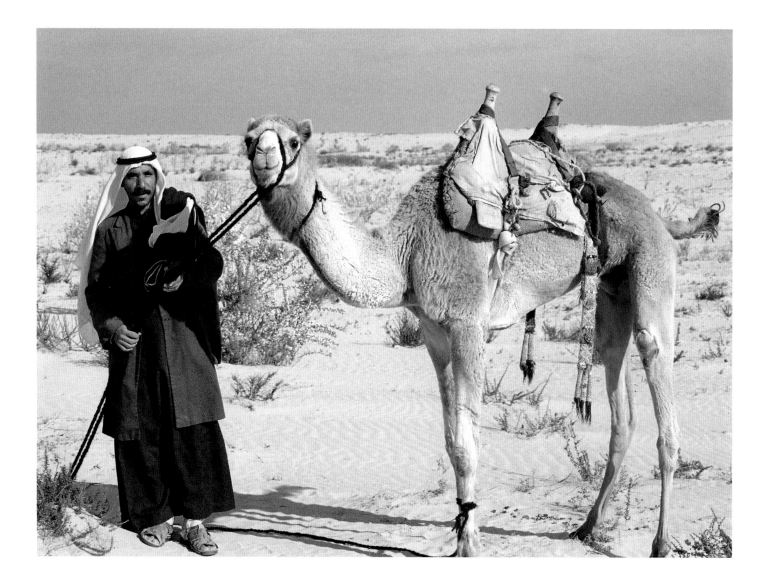

## Men and their Animals

The men in the villages of Egypt highly value their camels and water buffalo. While they often whip a donkey, a beast of burden, Egyptians treat their camels and water buffalo well, and always pose proudly when photographed with them. I observe a man and woman while walking on a narrow dirt pathway between fields of lettuce and cucumbers in the village of Kos near Luxor. They stop before the door of a house at the edge of the field.

*"Itfadali,"* Come in, he says, and invites me into his home, constructed of branches packed thickly with dried mud. He quickly introduces me to his wife and guides me over mud floors to the rear of the house, where he shows me his water buffalo. He asks me to take a picture of the two of them.

I have similar experiences with Bedouin men and their camels. One day I stop my car along the road to chat with a handsome Bedouin working in a field while his hobbled camel grazes nearby. He tells me that of his three camels, this one is his favorite. He is very pleased when I photograph them together.

Another time, I was visiting a Bedouin woman living near us in the North Sinai when her husband came in from working in the fields. Seeing I had my camera, he hastily changed into a snow-white *galabeya,* and took me out back to take a picture with his camel.

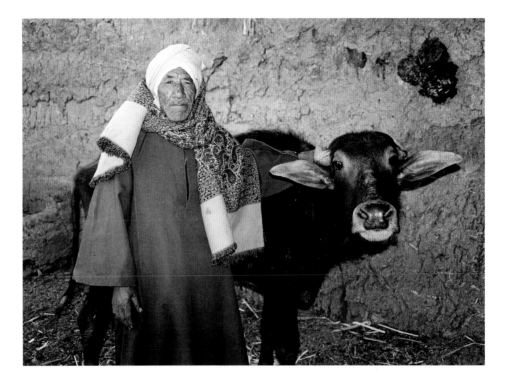

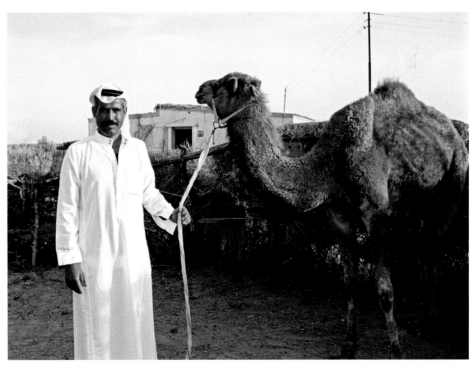

## Boabs in Zamalek

I stop our white Honda Civic in the narrow driveway next to our apartment building in Zamalek, the island in the Nile in Cairo. As I hand the keys to Ah-lam, our *boab,* I glance at the Honda's multiple "dings" from encounters with other cars, deep curbs, or roadway obstacles on the hectic streets of Cairo. I know it will look better after its daily wash inside and out by Ah-lam.

I think about Ah-lam's life as I take the elevator to our apartment overlooking the Nile. *Boabs* are the general caretakers of apartment buildings in Cairo. They can be seen every day sitting in doorways or in front of most apartments. Many come from Aswan in Upper Egypt, formerly part of Nubia. They are paid a small monthly stipend by each apartment owner, and pick up *baksheesh,* tips for doing odd jobs for tenants, such as carrying groceries or retrieving forgotten items. Being a *boab* is a demanding, low-paying, 24/7 job. Our *boabs* have no separate accommodations. Ah-lam sleeps in the lobby on a piece of cardboard, and makes his meals in a corner of the garage.

*Boabs* are known for their honesty and dedicated service. For example, about an hour after I arrive back at the apartment, Ah-lam knocks at the door, and hands me a thick roll of Egyptian pounds.

"I found this money in the door of your car, Madame Debbie," he says. "You must have forgotten it."

"Oh my glory, I certainly did forget it, Ah-lam," I answer gratefully.

I quickly take a ten-pound note from the roll of bills and hand it to him.

"Please take this for your trouble. I'm so happy you found the money," I tell him.

"Oh, no, Madam Debbie, I can't take that. It's part of my job," he tells me as he disappears into the elevator and returns to washing cars in the garage below.

As I close the door, I think about the honesty and integrity of the Egyptian people. I never fear for my safety when walking alone on the streets of Cairo at night. If I leave my purse in a coffee shop, the waiter will run out looking for me. Ah-lam, who struggles to barely support his family in Aswan, quickly returns the money he finds. I ask myself if this ethical behavior is due to the pervasive influence of the Muslim religion, or the close Egyptian family structure.

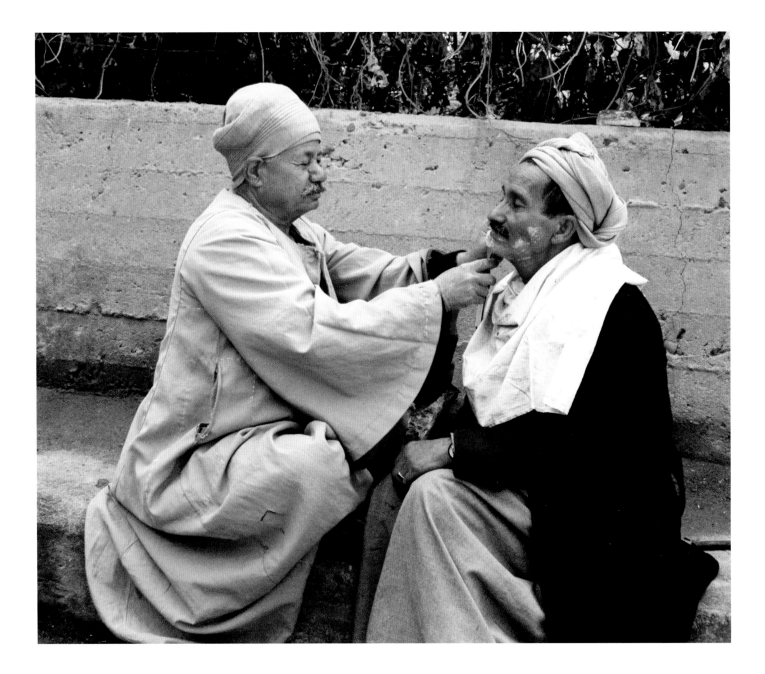

## Shaving

Barbershops are places where men gather for a shave, a haircut, or just conversation. In Egypt these shops take many forms. Some are in a regular storefront similar to most barbershops in America.

As I walk deep into the Khan el-Khalili, I encounter another type. I squeeze by a man having his hair cut while sitting on a chair plumped down right in the middle of a narrow alleyway. Further along I come upon a second man being shaved in another alleyway. These men are shaved or have their hair cut by a friend, not a regular barber.

My most unusual sighting is of two men taking turns shaving each other on a sidewalk high in the Mokattam Hills. Both men's eyes are closed, yet neither has a scratch on him!

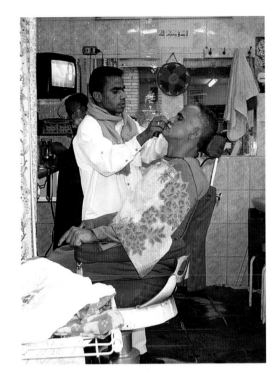

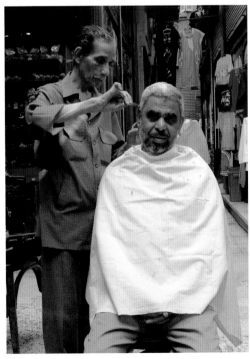

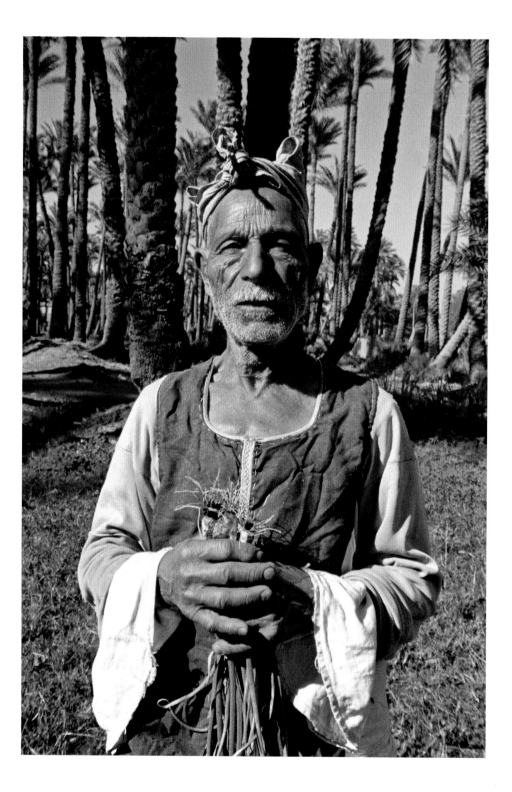

86

## Farming in Saqqara

Some of the richest Egyptian farmland outside the Delta is found along the road from the Giza Pyramids to the Step Pyramid of Saqqara. I park my car and walk along the edge of the green fields. A donkey, perhaps even pregnant, is tied to a wooden turnstile. She walks in endless circles, turning a waterwheel to transfer water from one field to another. This is performed in the shadow of the ancient Pyramids of Giza some distance in the background.

Further along, a man approaches bent almost in two by his huge basket, loaded with field greens. He tells me the greens will feed his water buffalo for the next week. In another field, I see a farmer with time etched on his sun-darkened face. He is harvesting green onions from the rich brown soil. His vest and *galabeya* are the same garb worn by Egyptian farmers down through the centuries. I tell him I'll return with his picture in another week.

*"Shukran, shukran,"* thank you, thank you, he tells me as he clutches his fragrant onions.

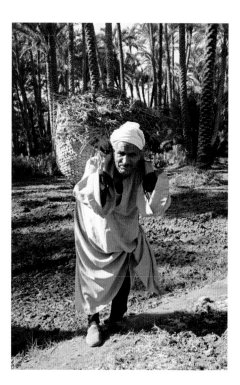

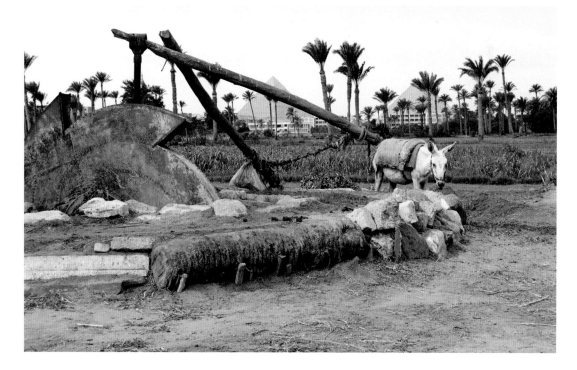

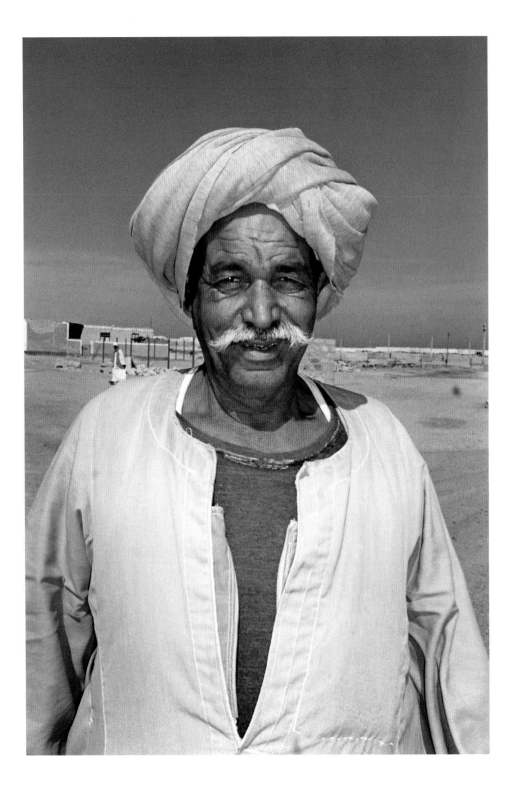

## Older Men

The timeworn faces of older Egyptian men fascinate me. They seem to enjoy their lives spent with family, sitting in cafés, or on benches near mosques. They drink tea, eat, and talk about life with anyone who comes by.

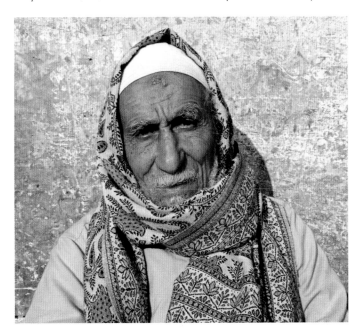

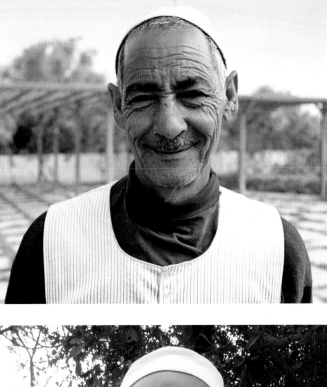

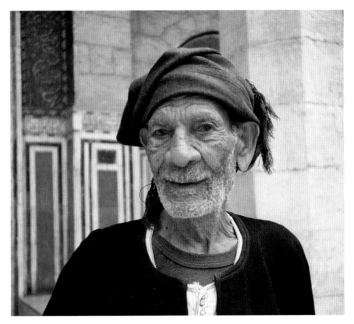

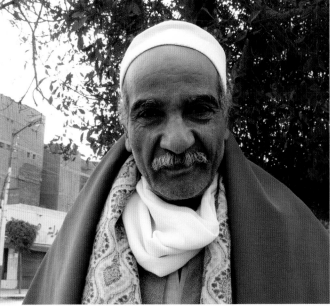

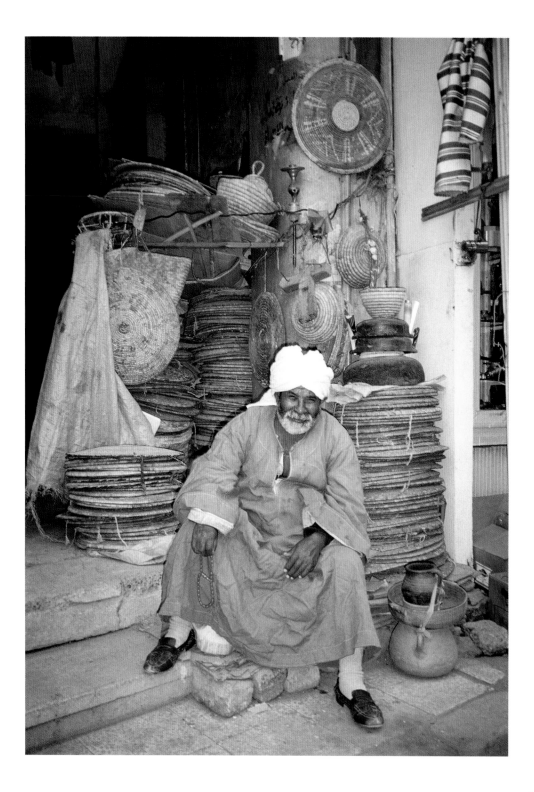

## Woven Mats and Baskets

The *souk,* or marketplace, of Aswan is
full of small shops with crafts to attract
tourists from all over the world. They
flock to see the ancient Pharaonic temples
and ruins in the area. This man watches
and encourages tourists to purchase his
intricately woven mats, coasters, and
baskets of every size and shape. Many
are woven from the fronds of date palms,
others from the tall grasses found along
the Nile.

"They are light and will fit easily into your
suitcase," he implores in English, Italian,
or French.

"Special price for a beautiful lady," he calls.

I yield to his sales pitch and to the beauty
of the design of one large circular mat.
When I see it on my family-room wall, I
remember the twinkling brown eyes and
infectious smile of the shopkeeper in
Aswan who sold it to me.

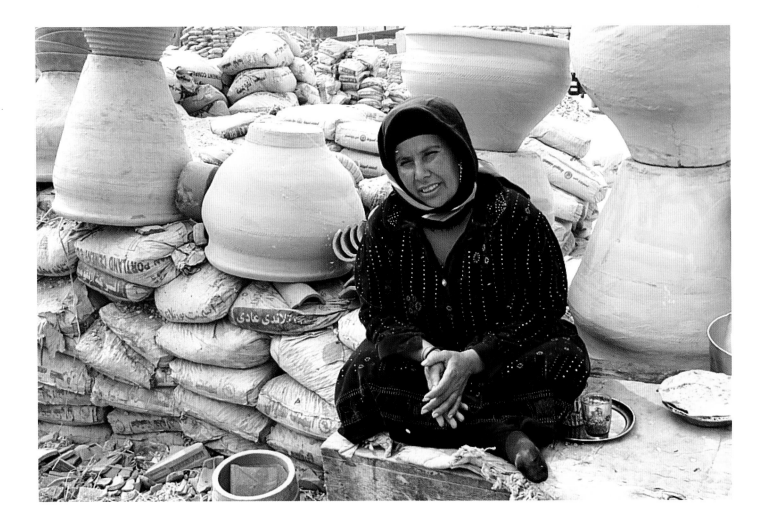

## Making Pottery

When the Islamic armies conquered Egypt in 641 CE, they set up camp at the old Roman fort of Babylon next to the Nile. This area eventually became known as Fustat, meaning tent, and it became Egypt's first Islamic capital.

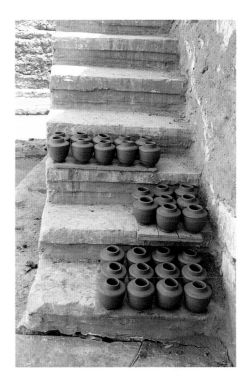

During the Fatimid period, 969–1171 CE, the capital moved farther north to Cairo. Over hundreds of years, the Fustat area became a community of earthenware craftsmen. They continue to fashion all sizes of pots, large amphoras, roof tiles, and even road-sized drainage pipes from clay found in the area.

Their craft is passed from father to son, with the women working in the home or helping to sell their beautiful pots to those who drive by.

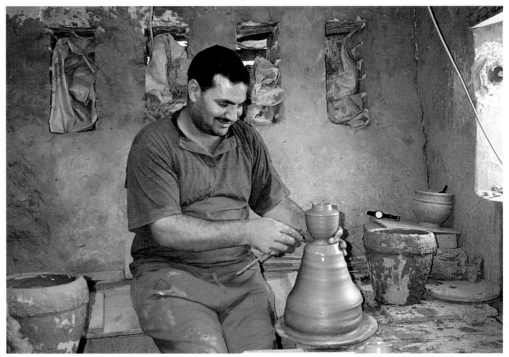

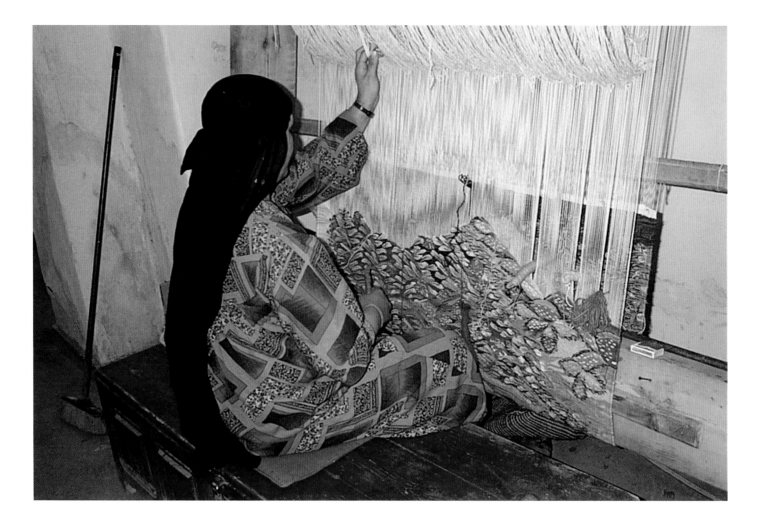

## Weaving Tapestries

Weaving tapestries and carpets is an ancient Egyptian craft. There are "Schools of Tapestry" and "Schools of Carpet Making" throughout Egypt, and many are found along the road from the Pyramids of Giza to the Step Pyramid of Saqqara.

Some of the most beautiful tapestries are created at the workshop of Wisa Wasa, where Suzanne Wisa Wasa fosters this ancient tradition. The women and men who weave these tapestries, filled with brightly colored flowers, figures, and scenes of Egyptian life, create them entirely from their imaginations.

I watch this woman for over an hour as she meticulously weaves a long horizontal hanging from her artist's vertical perspective. It's a time-consuming task and only a few inches will be woven by the end of each day. Several women work in the room, some with their young children playing or sleeping nearby. One tells me she's sixty years old, and has worked here all her life and loves her work. She's proud that many of the larger pieces from Wisa Wasa hang in the embassies and five-star hotels of Cairo.

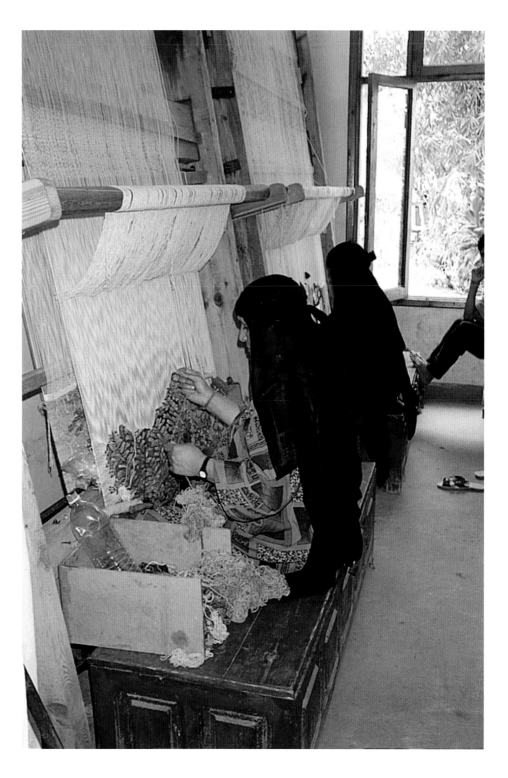

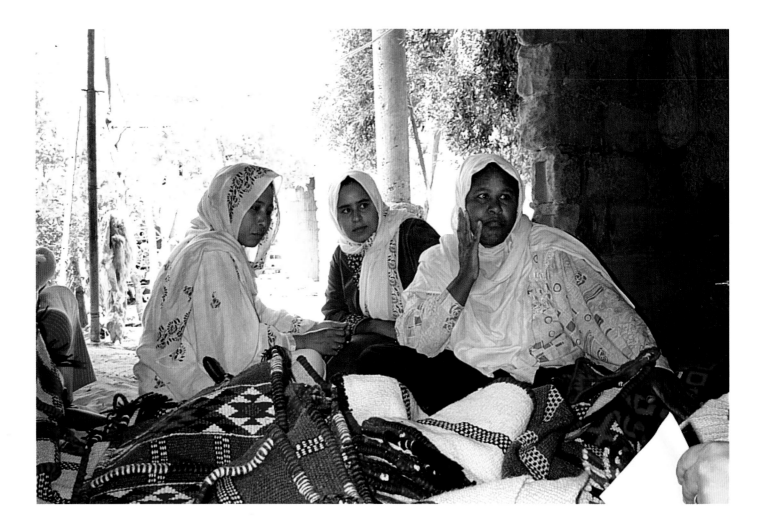

## Bedouin Women
## and their Crafts

I travel to a Bedouin home in a remote area of the North Sinai with Mahmoud and Samah, who plan to purchase hand-woven wall hangings and thick carpets *(kilims)* for a craft store in Cairo. As buyers for the Cairo market, they provide the Bedouin women of this area with a sales outlet for their crafts.

We have tea with an older woman and her two daughters. They bring out piles of their homemade products, representing more than a year's work. They explain that the wall hangings, room-sized *kilims,* and intricately designed shoulder bags are made from the wool of the family's sheep. The women shear the sheep, card the wool, dye, and weave it into the beautiful, richly colored products that surround them.

They bargain with Mahmoud, the middleman for the shop in Cairo. I cannot follow the entire discussion in Arabic, but silently cheer when it becomes clear these women refuse to sell their products until Mahmoud meets the price they feel they deserve for their year's labor.

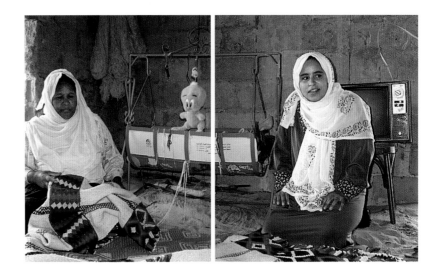

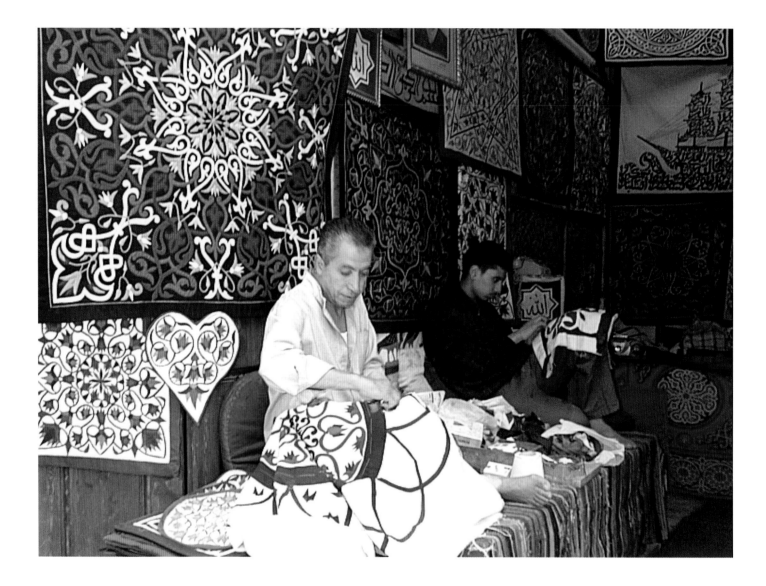

## The Street of the Tent Makers

I pay the friendly cabbie five Egyptian pounds (about $1.00) and walk south along Salah al-Din Street toward Bab Zuweyla, the southern gate in the medieval walls surrounding the Khan el-Khalili, Cairo's ancient bazaar. I'm heading toward the Street of the Tent Makers, a covered workshop area outside the gate devoted to the craft of appliqué.

Small stores and workshops line the sides of the crowded dirt roadway. I stop to watch women crowd round a man precariously perched on a rickety three-legged stool as he throws brightly colored nightgowns packed in cellophane bags to their outstretched arms. He shouts out the price, keeping a cigarette balanced in the corner of his mouth.

A hissing sound warns me that I should move aside for a man pushing a wheelbarrow piled five feet high with flimsy cardboard boxes. A boy on a bicycle follows him closely, balancing a six-foot-long tray of pita bread on his head.

I watch a toothless man in grease-stained yellow *galabeya* pile fried bread into cone-shaped newspapers for a mother and her young daughter. The smell of roasted peanuts draws me farther along the crowded street. I stop to buy some.

At a small workshop I watch a man take dark red felt, fit it around a copper-colored mold and create a fez, or *tarbush*, as it's known in Egypt. He motions for me to come in and I nibble on my warm peanuts as I watch him create another fez.

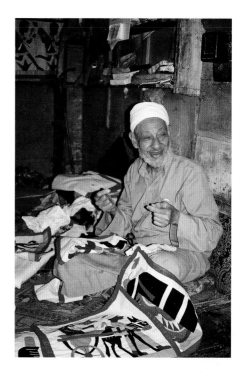

Continuing toward the Street of the Tent Makers, I see men smoking sweet-smelling, apple-flavored tobacco in their water pipes *(sheesha)* as they drink tea and watch the street commotion in front of them.

Passing workshops filled with wire mousetraps, wooden mallets, spoons, and plates, and shops selling handmade folding chairs with striped canvas seats, I see the ancient gate just ahead, its huge wooden doors open to the street beyond.

Now I've reached the Street of the Tent Makers, with workshops on either side where men sit sewing. The ancient craft of appliqué is passed from father to son in these small workshops, owned by families for many generations. Brightly colored cotton is appliquéd into intricate arabesque designs and then made into pillow covers, wall hangings, bedspreads, and even tents for funerals or desert gatherings.

One man tells me he is seventy-one and has worked in his shop for more than fifty years. He loves to create things and never tires of his work—or of people like me who stop to watch him. I hope his eyesight allows him to keep sewing as long as he lives.

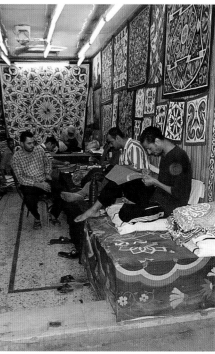

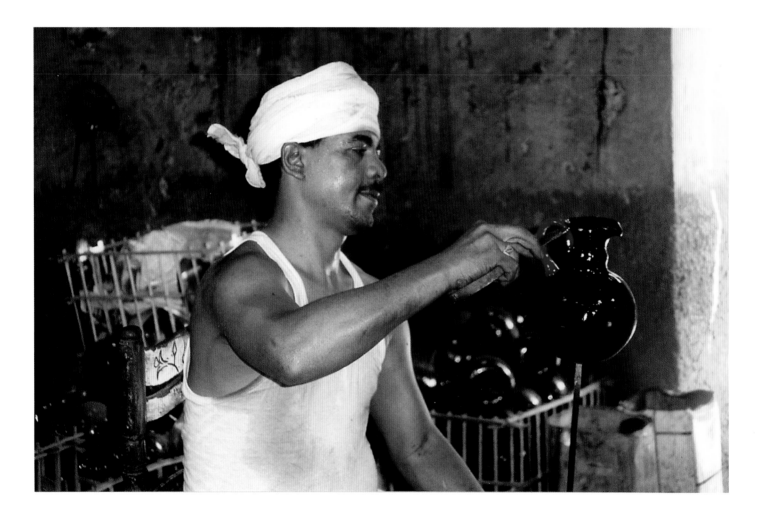

## Blowing Muski Glass in the City of the Dead

It's another warm sunny day in Cairo as I ease my car through the narrow winding streets of the City of the Dead, en route to Qait Bey Mosque. I pass several family gravesites, and tell my guests from the States that many of these sites go back to the 1600s, when the cemetery was outside the city walls. Today it is part of a teeming, bustling city. Dead people are still being buried here, but this is also home to more than a half million people who live among the dead in either abandoned family gathering rooms or newly constructed buildings. Shops and schools are also part of this area.

After visiting the mosque, we enter a narrow gateway and head toward a workshop where two young men are blowing glass. Near the door of the shop are piles of recycled bottles, sorted by color. Many are broken, but some still hold the labels of the soda, beer, tomato sauce, or tahini they once contained.

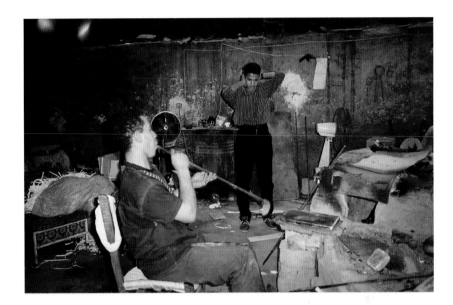

The heat from the furnace is stifling. The men, stripped to their undershirts, expertly maneuver bulbs of hot molten glass from a furnace onto the end of long metal rods. They slowly blow and guide the molten mass into the shape of a glass, vase, candlestick, or plate.

When the blown object reaches the desired shape, the worker carefully knocks it off the rod, and places it on a nearby wooden pallet. Sweat rolls from his forehead as he starts this same procedure over again. My Egyptian friend Ola, who introduced me to this workshop, told me that this family has been blowing glass in this same location for over two hundred years.

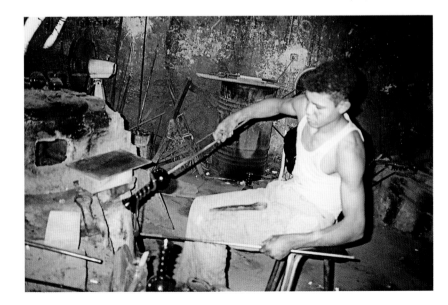

Crafts

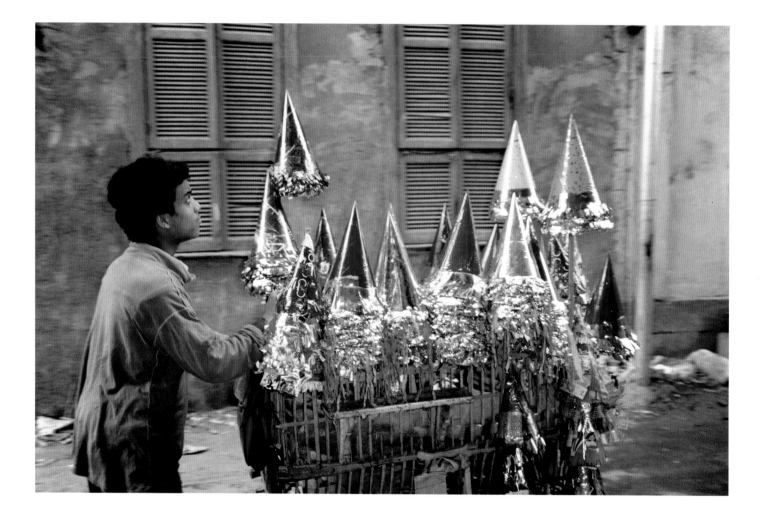

## Moulids

A *moulid* is the celebration of the birthday of an Islamic saint. The most famous is the *Moulid* el-Naby, which marks the birthday of the prophet Mohammed. Many *moulids* are observed in the villages of Egypt and are dedicated to a local saint. It is a time when family and friends gather to feast and celebrate. Special sweets, molded for the occasion, are a favorite treat at most *moulids*.

In Cairo, the Moulid of Sayeeda Zeinab, the prophet's granddaughter, takes place at the mosque of the same name where she is buried. It is often attended by almost a million people. Another very popular *moulid* is the Moulid of al-Rifa'i Mosque. The man with the cymbals is in the *zaffa*, parade, at this *moulid*. A father and his daughter, wearing a picture of an Islamic holy man, are also marching in the *zaffa*. Drums, cymbals, and ululating women accompany celebrating marchers as they parade through crowded streets from al-Rifa'i to Sayeeda Zeinab Mosque.

Along the way, vendors sell paper hats, sweets for the children, beads, and soft drinks. The young child wearing the hat helps attract customers to his father's cart.

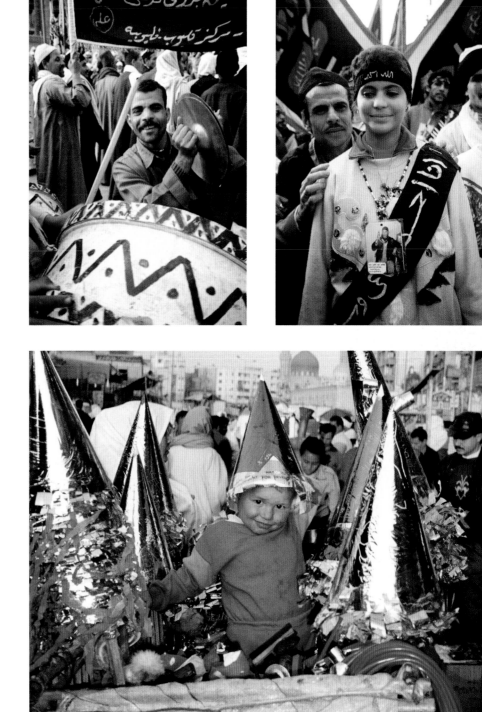

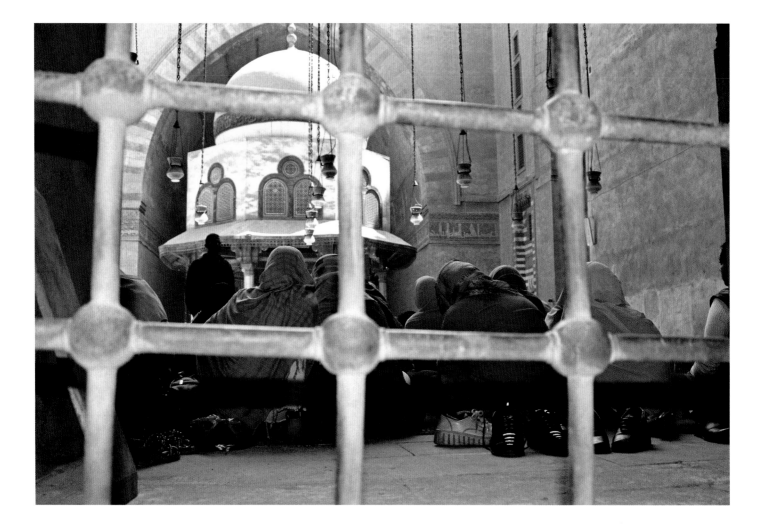

104                                                                                    **Faces of Egypt**

## Women in Sultan Hassan

Sultan Hassan is an enormous mosque near a beautiful square *(midan)* in Old Islamic Cairo. It is next to the very impressive al-Rifa'i Mosque, and both are situated within view of the steep walls of the Citadel.

Sultan Hassan was built between 1356 and 1363 CE, during the Mameluke period. Its central courtyard has four recessed arches or *liwans,* each devoted to the study of one of the main schools of Sunni Islam.

Five times a day Egyptian Muslim men answer the call to prayer, and can come to any mosque to pray. Women usually pray at home. When touring Sultan Hassan to study its fourteenth-century stonework and intricate carvings in early Arabic script, I am surprised to see these young female students in one of the *liwans.* Like everyone in any mosque, they have removed their shoes, and listen intently to the theological lesson from one of the leaders of the mosque.

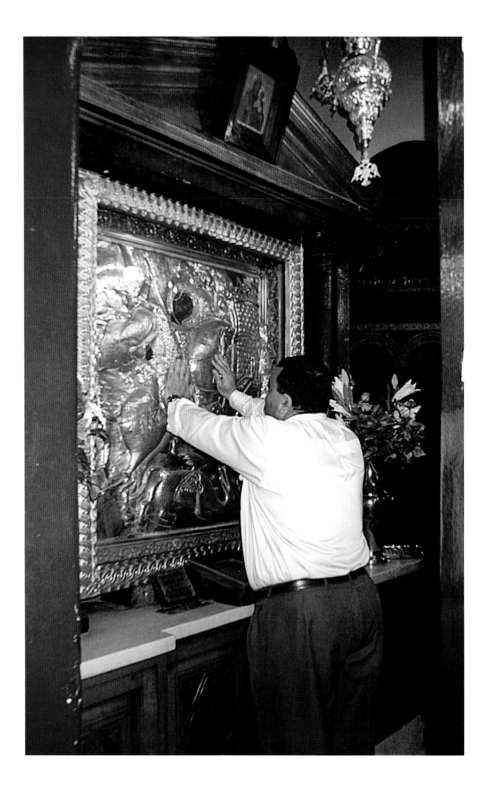

# Christianity

Ninety-five percent of Christian Egyptians are Coptic Orthodox. They make up almost ten percent of Egypt's population. "Copt" comes from the Greek word for Egypt, *Aigyptos*. Christianity was introduced into Egypt during the first century; by the third century, the Bible had been translated from Greek into the Coptic language, a hundred years ahead of the Latin Bible.

Monastic life has strong roots among the Copts and Eastern Orthodox Christian religions. Beautiful Coptic churches and monasteries were built, some dating from about 400 CE. There are several monasteries along the desert road from Cairo to Alexandria at Wadi Natrun. The exquisite roofline of St. Bishoi is one of the most outstanding features of these Wadi Natrun monasteries.

By 350 to 400 CE, monks were living in desert caves along a wadi about thirty kilometers from Zafarna on the Red Sea. St. Anthony, the first documented Christian hermit, lived in a cave above a rock spring in this area. His followers founded the beautiful St. Anthony's Monastery (upper right) in 356 CE, following his death. It claims to be the oldest monastic settlement in the world. The Greek Orthodox Monastery of St. Catherine's, lower right, was built by the Emperor Justinian about 530 CE. It attracts visitors from all over the world who come to view its historic icons.

The man on the left reverently places his hands on the gold icon of St. George in a church in Old Cairo. He is venerating the saint, who is said to have slain a dragon and was martyred for his Christian beliefs. The man remains there for several minutes fervently praying, while the smell of incense from a golden vessel permeates the church.

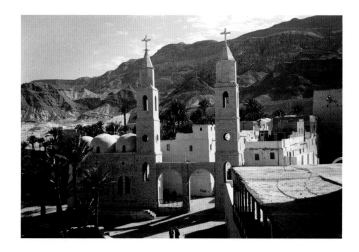

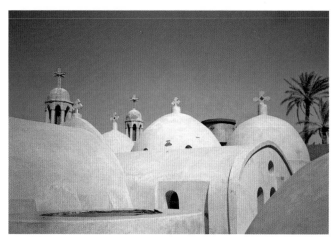

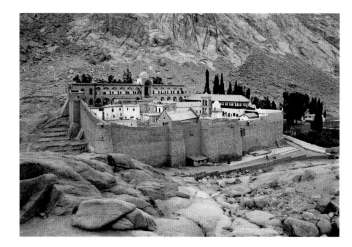

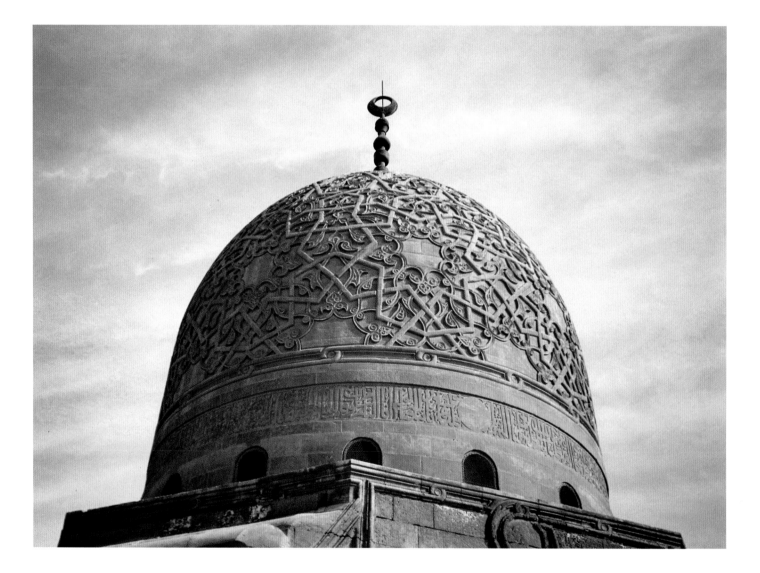

## Mosques and Minarets in Cairo

Cairo is full of mosques and is known as the city of 1,000 minarets. Many date from the city's earliest history. Chants from tall minarets next to the mosques call Muslims to prayer five times a day. The call to prayer may be a live chant from an imam or a recorded chant piped from speakers at the top of the minarets.

Men in Qait Bey Mosque in the City of the Dead answer the noonday call and come to the mosque to pray. This mosque dates from 1474 CE. Its decorative dome combines geometric and floral designs, and its image is imprinted on the Egyptian one-pound note.

If you aren't near a mosque at prayer time, any area can be a temporary prayer area. This place on the west bank of the Nile across from Luxor Temple is set aside for prayer. The straw mat and rocks define the space, and the men remove their shoes as they face east toward Mecca to pray. The leader directs the prayers in Arabic and the faithful stand, kneel, or prostrate themselves as they pray.

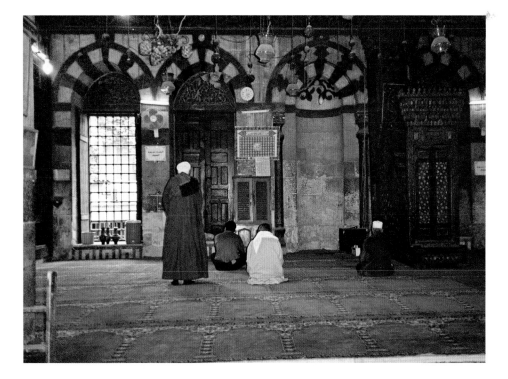

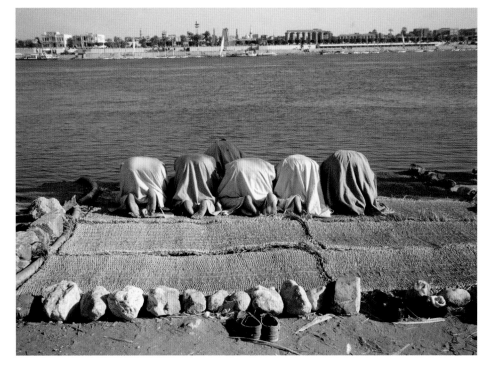

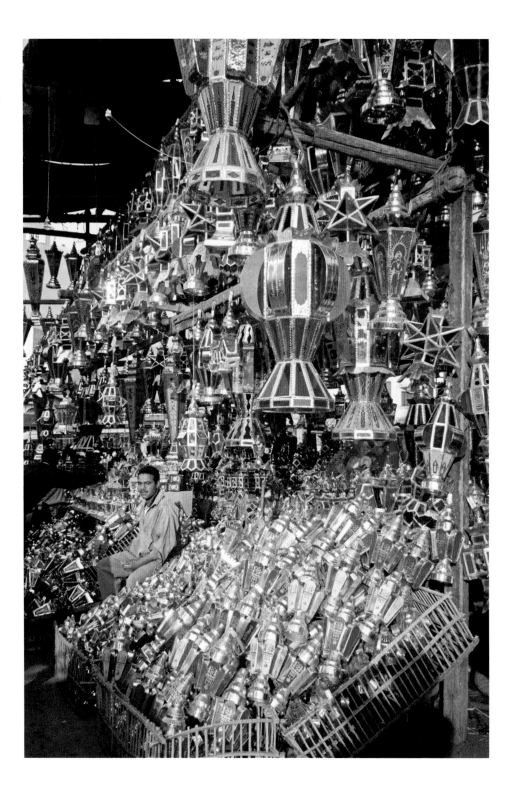

## Ramadan

Ramadan is the ninth month of the Islamic calendar, marking the time when the first revelations enshrined in the Qur'an were revealed to the prophet Mohammed. It's the month when healthy adult Muslims and sometimes children as young as ten fast from sunrise to sunset.

In Fatimid times, the streets of Egypt in Ramadan were always decorated with lanterns. These lanterns, or *fanous,* were used to light the procession to await the disappearance of the moon, signifying the start of each day's fasting.

Today lanterns are hung over streets and at people's houses. The lanterns come in all sizes and shapes and are available in many parts of Cairo just before Ramadan.

Each year a man who lives nearby hangs these colorful lanterns (top right) from the trees in a traffic circle in Maadi.

Taking care of the poor is one of the five Pillars of Islam. During Ramadan, tables for the poor are found near mosques, in the Khan el-Khalili, and throughout every city and village. Wealthy people donate food and money so that all the poor of the country are well fed at the *iftar* meal for the breaking of the fast at sundown.

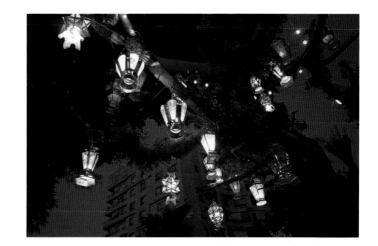

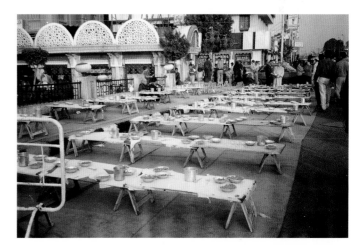

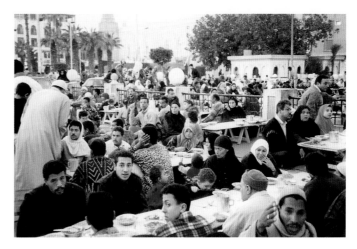

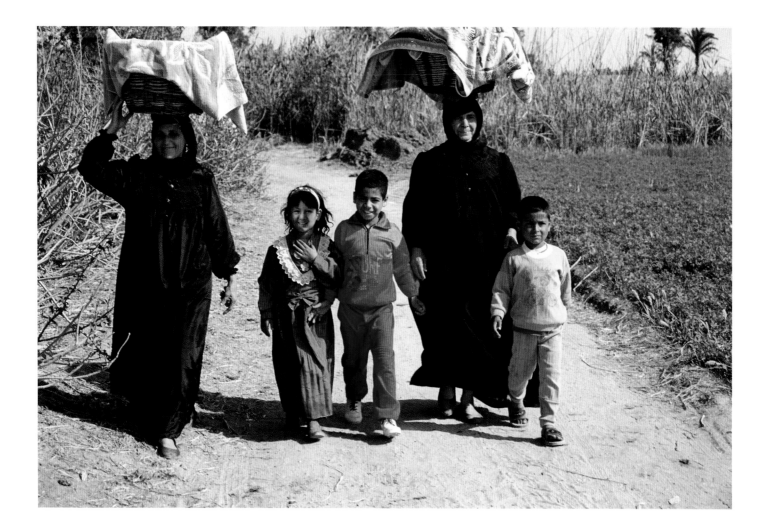

## An Egyptian Legend

In the Beginning, floodwaters engulfed the world. Nothing stirred amid that dark and dismal expanse. Then, miraculously, a lotus blossom surfaced and opened its petals to give birth to the Sun.

Rising from the blossom like a golden bird, the Sun subdued the waters and coaxed life from the emerging land.

Ever after, when the Nile receded and the growing season began, its people gave thanks to the sun god Ra and to his earthly counterpart, the Pharaoh, who claimed divine powers and kept the country fruitful.

# Acknowledgments

There are many people who played a role in the creation of this book. Ola Rashad Seif explored the Khan, Old Islamic Cairo, and the City of the Dead with me, giving me insights into the history and people of these areas.

Ola also designed the first prototype of this book. Her mother, Magda Lawrence, was my first Egyptian friend and remains a true friend to this day. She provided me with a deeper understanding of the Egyptian culture.

Jeanette El Wakeil, an excellent photographer, tramped the villages and farms of the Saqqara region with me during my early days in Egypt. Ahmed el-Sherify, our driver, my Egyptian "brother," has an eye for excellent pictures and drove me in his red 1976 Mercedes to explore many unfamiliar parts of Egypt.

My appreciation to Mari Messer and everyone in the Naples Writers' Forum for their encouragement and gentle suggestions that greatly helped with the written sections of this book.

My greatest thanks go to Barbara Whitesides, the author of *Sugar Comes from Arabic: A Beginner's Guide to Arabic Letters and Words,* who carefully edited this book and motivated me to get it published.

I am also indebted to Geoffrey Piel, who designed the book's pages and its cover.

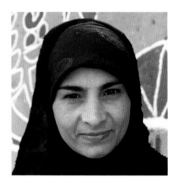